Undergraduate

book fund

contributed by
friends of Stanford

THE FOLK ART TRADITION

THE FOLK ART TRADITION

NAÏVE PAINTING IN EUROPE AND THE UNITED STATES

JANE KALLIR

Foreword by
Dr. Robert Bishop

Galerie St. Etienne
and

A Studio Book
The Viking Press
New York

Exhibition dates:
November 17, 1981 — January 9, 1982

Galerie St. Etienne
24 West 57th Street
New York, New York 10019

Heartfelt thanks are conveyed to all those who so generously provided photographs: the Brooklyn Museum, Brooklyn, New York; Christie, Manson & Woods, International, New York; Hirschl & Adler Galleries, New York; the Hirshhorn Museum and Sculpture Garden, Smithsonian Institution, Washington, D.C.; the John G. Johnson Collection, Philadelphia, Pennsylvania; Mrs. Jacob M. Kaplan; Kennedy Galleries, New York; the Library of Congress, Washington, D.C.; the Metropolitan Museum of Art, New York; the Museum of Art, Rhode Island School of Design, Providence, Rhode Island; the Museum of Fine Arts, Springfield, Massachusetts; the Museum of Modern Art, New York; Roy R. Neuberger; Perls Galleries, New York; the Phillips Collection, Washington, D.C.; Mr. and Mrs. Meyer P. Potamkin; the Norton Simon Foundation, Pasadena, California; the Smith College Museum of Art, Northampton, Massachusetts; Valley House Gallery, Dallas, Texas; the Whitney Museum of American Art, New York; the Worcester Art Museum, Worcester, Massachusetts; and a number of private collectors who prefer to remain anonymous.

Published in 1982 by The Viking Press (A Studio Book)
625 Madison Avenue, New York, N.Y. 10022
Published simultaneously in Canada by Penguin Books Canada Limited

Library of Congress Cataloging in Publication Data
Kallir, Jane.
 The folk art tradition.
(A Studio book)
1. Folk art — Europe. 2. Folk art — United States. 3. Primitivism in art — Europe. 4. Primitivism in art — United States. 5. Art, Modern — 19th century — Europe. 6. Art, Modern — 19th century — United States. 7. Art, Modern — 20th century — Europe. 8. Art, Modern — 20th century — United States. I. Title.
NK925.K3 745 81-16057
ISBN: 0-670-32325-X (Cloth) AACR2
0-910810-20-6 (Paper)

Cover, Plates 18, 19, 20, Figures 40, 41, 56, 57, 58, 59, 60, and quotes by Grandma Moses, Copyright © 1981, Grandma Moses Properties Co., New York.
Plate 25, Copyright © 1980, Nan Phelps.
Figures 13 and 14, Copyright © 1976, Office du Livre, Fribourg, Switzerland.
Figures 23 and 24, Copyright © 1974, E. Boyd.
Figure 34, Copyright © 1977, Time-Life Books, Inc.

Photographs by Eric Pollitzer: Cover; Plates 1, 2, 4, 7, 12, 15, 16, 18, 19, 20, 24, 25, 26, 27, 28, 29; Figures 2, 6, 8, 10, 11, 16, 18.

Designed by Gary Cosimini
Printed by Rapoport Printing Corp., New York
Printed in the United States of America

Cover: Anna Mary Robertson Moses. Old Times (detail). 1957.

Contents

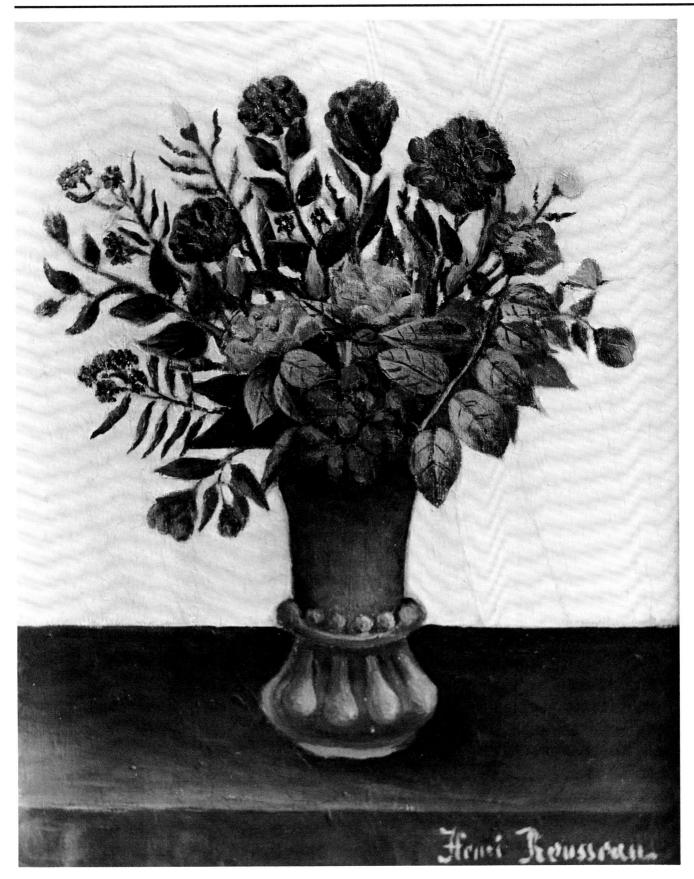

Figure 1. **Henri Rousseau.** Flowers in a Vase. 1909–10.

Foreword

by Dr. Robert Bishop, Director, Museum of American Folk Art

In the field of human endeavor there have been pioneers who have been gifted with the foresight to perceive, to bring to fulfillment, and to interpret for the rest of us important new areas of knowledge. Otto Kallir (1894—1978), art scholar, historian, and founder of the Galerie St. Etienne in 1939, was such a man. His trailblazing efforts in developing appreciation for nineteenth- and twentieth-century European and American masters on the part of museum curators and private collectors is well documented. Equally impressive were his daring exhibitions devoted to the American naïve master, Anna Robertson Moses (1860—1961), known to the world as Grandma Moses.

When asked by Hildegard Bachert and Jane Kallir to serve on a committee for several exhibitions to be mounted at the Galerie St. Etienne in 1980—81 to honor the late Dr. Kallir, I readily accepted. This book, *The Folk Art Tradition,* by Otto Kallir's granddaughter Jane Kallir, is a by-product of the third exhibition in this memorial series. With this publication, Ms. Kallir demonstrates her keen and deep understanding of the central role of folk art in the history of world art. In a manner and style that would delight her most precise and articulate grandfather, she has presented traditional ideas about the subject in a very fresh, insightful way. In addition, she has formulated new concepts of her own which will surely merit widespread acceptance. Her keen understanding of the relationship of the crafts to the folk traditions and to the efforts of the professional American folk artists of the eighteenth and nineteenth centuries is illuminating. She has also demonstrated an extraordinary ability to cut through the obfuscation in the literature of art history as it concerns twentieth-century American folk art.

As Ms. Kallir demonstrates, there is, of course, a valid twentieth-century folk art. In our own century creativity is no longer based solely upon transplanted European peasant traditions. It is a flowering of America for and by the American people. Sometimes inspired by religious enthusiasm, sometimes by patriotic zeal, sometimes highly finished and sometimes painfully crude; at its best it provides a richly textured document of both time and place. On occasion I have been accused of being a champion of twentieth-century folk art. I am not. I appreciate quality, whenever and wherever it occurs. It gives me great pleasure to pen this foreword, for I believe this book and the exhibition that inspired it are yet another turning point in the development of a deeper understanding of the best qualities of folk art regardless of when or by whom it was created.

Introduction

It has become standard practice for studies of folk art to begin with a theoretical discussion of the meaning of the term. To readers with some advance conception of the subject matter, this persistent need to define and redefine may prove puzzling. Most people may not be able to provide a textbook definition of "folk art," but will, if pressed, contend that they "know it when they see it." Scholars, on the other hand, are sometimes handicapped by an inability to see if they do not know beforehand what to expect. Both attitudes can prove inimical to the understanding of art, folk or otherwise.

In defense of the scholar, it must be said that a general confusion regarding the concept of folk art does to some extent justify the multiplicity of definitions. This may in part be explained by the fact that, whereas formal movements in art are generally determined by style, the notion of folk art is determined by attitude. Prevailing attitudes, until the turn of the century, recognized only one art — that of the academic tradition generated by the Renaissance — as supreme. A gradual change in attitude drew attention to a host of nonacademic works previously judged inept. Into this group fell a variety of objects bearing only slight stylistic similarity, produced by people who, though exposed at least fleetingly to European high culture, were unable to successfully emulate it. The category includes such diverse items as whirligigs and watercolors, pottery and paintings, quilts, embroidery, toys, farm implements, kitchen utensils, devotional objects and furniture. The artists range from professional craftsmen to schoolchildren, from peasants to patricians. In short, the scope of the art and artifacts produced by folk culture is as broad as that of high culture, and the qualifications of its practitioners are, if anything, broader.

The concept of folk art is one of negation. It is a catchall category for misfits — wallflowers at the dance of Western civilization. Like all things defined in the negative, the concept remains strongly dependent on the thing negated. One cannot have a clear understanding of folk art without a clear understanding of academic art, for only then can one perceive the differences that distinguish the two. Moreover, folk art in all its varying manifestations retains perceptible ties to the academic tradition.

The folk art dilemma is exemplified by the number of terms that have been used to describe it. Some of these terms, such as "pioneer" or "provincial," enjoyed only a brief vogue due to their overly restrictive implications. Of the terms that have endured, "folk" is the adjective of preference today in the United States, used for art of both this and previous centuries. In Europe, "folk" is reserved primarily for the discussion of pre-modern peasant creations. Henri Rousseau, the first "naïve," has passed this adjective along to his European successors. "Primitive" remains a strong runner-up on both continents, and "self-taught" is useful when speaking of the artists themselves (as opposed to the works they create). With the exception of "self-taught," which is literally descriptive, all the terms express the opposition of subjective attitudes: primitive as opposed to civilized; naïve as opposed to sophisticated; folk as opposed to elitist. No single adjective seems entirely satisfactory. The concept of "folk" art, despite earnest defense on the part of American scholars, cannot be entirely divorced from the image of rural Europe and is, in any case, more appropriately confined to a crafts context. The word "naïve" remains inextricably bound to the legend of Henri Rousseau and places an unfortunate emphasis on the artist's personality. "Primitive" evokes too wide a range of aesthetic categories, from prehistoric artifacts to the work of pre-Renaissance Italian masters. Of all the terms, "self-taught," despite the existence of folk artists who had some formal training, is the most inoffensive. Though hesitant to add to the existing confusion, this author prefers the word "nonacademic" because it most closely conveys the art-historical genesis of the field. However, as no one term has yet become universally accepted, all the above words will be used here more or less interchangeably. We do, indeed, know it when we see it, even if we do not know what to call it.

Asked to define "folk art" at a symposium on the subject, Holger Cahill, one of the pioneering scholars in the field,[1] replied: "The material will define itself if one will allow it to do so."[2] While this is a logical and straightforward approach, in practice things have seldom worked out so simply. Because folk art was, until the twentieth century, relatively unappreciated and unrecorded, initial research in the field tended to be overly comprehensive. One of the first books on American folk art, written by Jean Lipman in 1942, already bemoaned the ill effects produced by the "undiscriminating enthusiasm of discovery and crusade."[3] Unearthing neglected nineteenth-century masterpieces in some rural hideaway or, alternatively, locating a present-day Rousseau, had become a pursuit relished as an end in itself. The evidence accumulated through these efforts was tabulated in numerous descriptive books detailing the life stories and achievements of the artists in question. The primary pur-

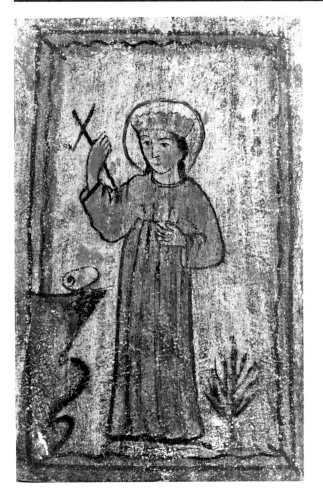

Figure 2. **Anonymous New Mexican Artist.**
Santa Rosalia. 19th century.

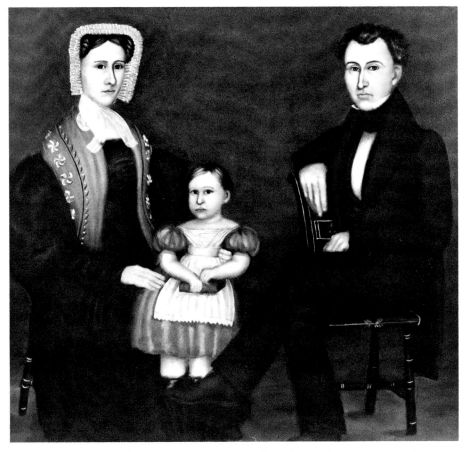

Figure 3. **Anonymous American Artist.** Family Portrait. 19th century.

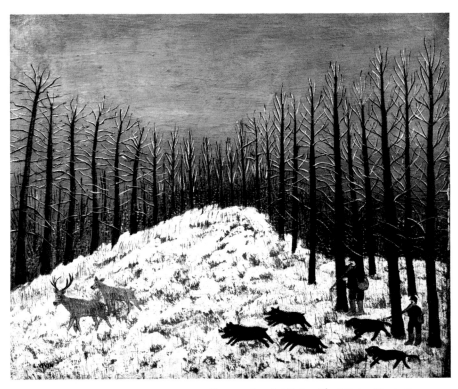

Figure 4. **Louis Vivin.** The Winter Hunt. Ca. 1925.

pose of the books was documentary, and often the authors themselves were the first to acknowledge that not all of the art included was of equal merit.[4] However, the number of artists involved made it difficult to come to terms with the field as a whole.

The purpose of this book is to provide an analytical (as opposed to a descriptive) overview of nonacademic painting in Europe and the United States. The scope has deliberately been restricted almost exclusively to painting because it is the author's conviction that folk painting represents a tradition quite distinct from folk crafts. The number of artists under discussion has been kept relatively small. An attempt has been made to intermingle works by most of the better-known artists with that of lesser-knowns, but the selection is intentionally not comprehensive. By summarizing the main components of the folk tradition in Europe and the United States, interrelationships concealed by more detailed accounts become visible. It is hoped that the present approach will provide new insights into a field that has thus far been difficult to define.

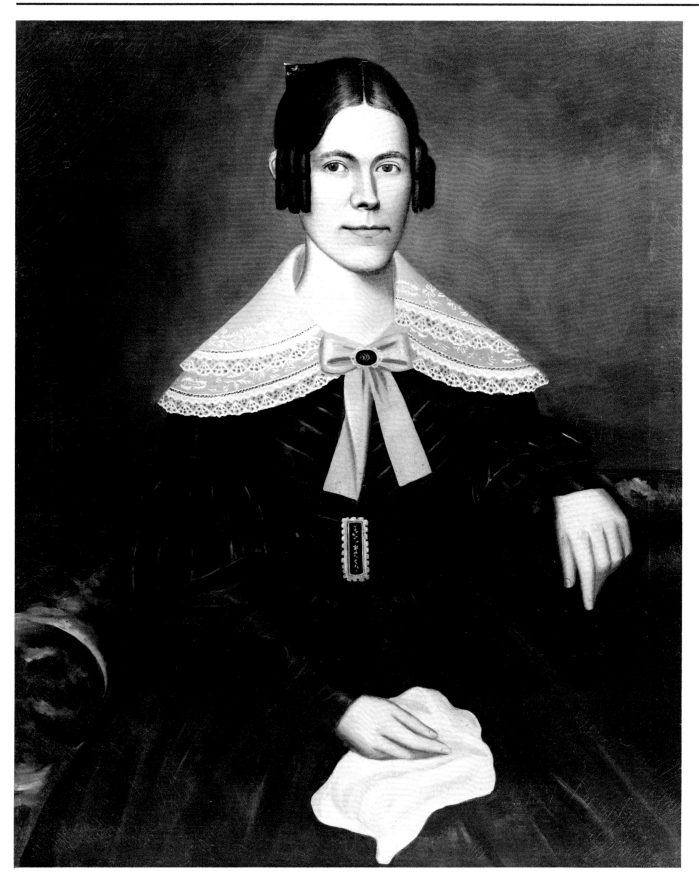

Figure 5. **Erastus Salisbury Field.** Portrait of Susan Maynard Shearer. Ca. 1833.

Background:
Arts and Crafts
in Europe and
the United States

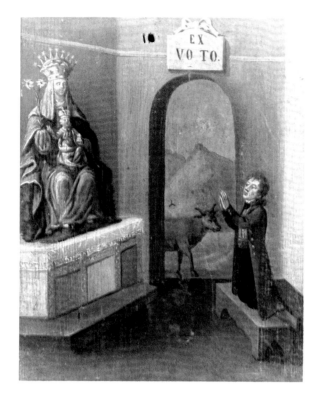

Figure 6. **Anonymous Austrian Artist.** Supplicant in Alpine Chapel with Cow. Ca. 1800.

Figure 7. **Anonymous Austrian Artist.** Iron Votives: Blacksmith and Pig.

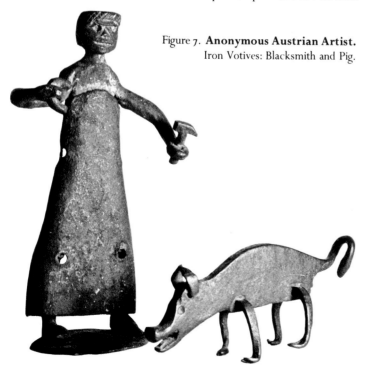

In the Middle Ages, there was no nonacademic art because there was no academic art. The notion of the artist as a special human being had not been developed. Artists were simply craftsmen, along with cobblers, furriers, tailors, and carpenters. Some, granted, were better at their crafts than others. It was partly through the esteem accorded such notables as Giotto that the artist began to transcend the ranks of his fellow craftsmen. The revived interest in classical texts that ushered in the Renaissance provided exposure to a more elevated conception of art. Humanistic and stylistic innovations also served to distinguish the art of the Renaissance from that of the Middle Ages.[5]

The Renaissance spread with varying degrees of speed across Europe. In some remote areas, medieval traditions were slow in dying out. Hungarian peasants, for example, remained under feudal domination until 1848. Switzerland, on the other hand, was never exposed to the feudal system at all. In many respects, European folk art may be seen as a continuation of the medieval craft system. Even in areas profoundly influenced by the Renaissance, the older tradition continued to exist and evolve, creating a bivalent cultural structure which to some extent survives to this day.

The folk art tradition, far from being spontaneous or uninfluenced, was based on a fairly rigid set of standards and practices. In France, for example, certain basic models were transmitted from town to town and from generation to generation. Itinerant craftsmen traveled throughout northern Europe spreading ideas and approaches. Styles and techniques might be passed along orally from master to apprentice, or conveyed in printed manuals. Tools and templates, such as the woodblocks used to make popular prints at centers like Epinal, were handed down from one generation to the next.[6] Such prints themselves became carriers of the folk tradition. They were often nonacademic interpretations of academic motifs. Used as source material by craftsmen working in other media, these motifs were retranslated into decorative emblems.[7]

The pronounced crafts structure of European folk art belies the notion of independent peasant creators. However, the range of professional outlets for the folk artist varied from one region to another. Some were, indeed, farmers or herdsmen who pursued a folk craft in their

spare time. At the other extreme stood the highly trained craftsman. In between the two lay a myriad of possible variations.

Regardless of training or professional status, these artists created objects that were primarily group—oriented. This does not mean that the individuality of the artist was suppressed or excellence unappreciated.[8] Nonetheless, folk art served a communal function and was geared to well-established customs of design and technique. Perhaps for this reason, few self-motivated paintings were produced. Most creations were utilitarian, and painting was confined to a basically decorative role. Elaborate scenes might adorn cupboards or crockery, but art-for-art's-sake was an unfamiliar concept.[9]

Just as the nature of the artist/craftsman varied from one area to another, so did the nature of his market. Some served a highly structured industry, others an amazingly informal trade. While many goods were produced for a local market, sophisticated distribution networks were also in operation. Peddlers traveled throughout the land selling their wares. For more far-flung enterprises, specialized middlemen might be called into action.[10] Periodic trade fairs functioned as centralized distribution points and facilitated the interchange of styles and methods.[11]

Though certain items were distributed across the continent, regional styles did develop. Present-day national boundaries are handy for discussion purposes, but the art itself generally reflects less cohesive distinctions. Thus the folk art of eastern France has much in common with that of western Germany, while the art of northern Germany reflects a Scandinavian influence. Some distant regions were penetrated by few outside forces. Eastern Europe was remote culturally as well as geographically. In Hungary, the post-Renaissance separation of folk art from high art did not occur until the 1700s. At that time, many guilds split into two branches. The "Germans," influenced by trends to the west, served the aristocracy, and the "Hungarians" served the more conservative peasants. Nonetheless, what was considered high art in Hungary might well be labeled folk art in another land. A carved folk wardrobe from Germany could be regarded as the height of fashion by a Hungarian nobleman accustomed to the painted chests common in his native country.[12]

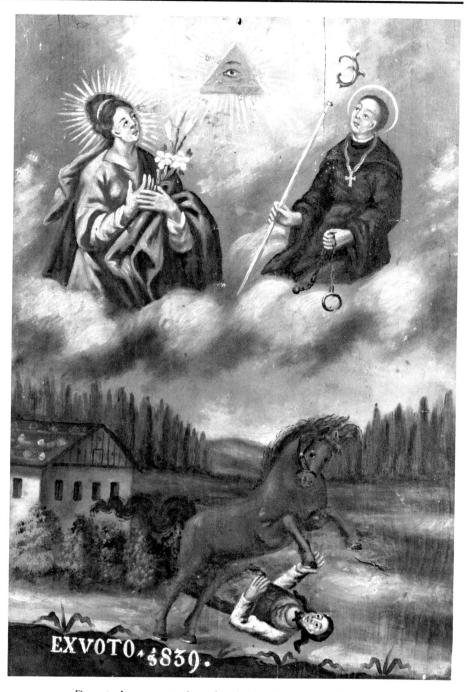

Figure 8. **Anonymous Austrian Artist.** Woman Being Trampled by Horse. 1839.

Figure 9. **Conrad von Soest.** The Nativity (detail). 1403 – 04.

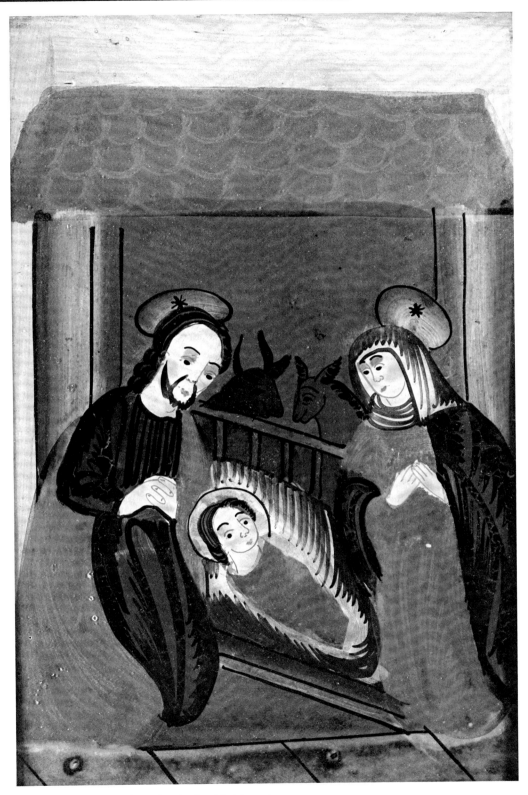

Figure 10. **Anonymous Austrian Artist.** Nativity. 19th century.

Religious Folk Art

Without a doubt, the most extensive tradition of autonomous folk painting in Europe is religious. The Church not only provided motivation for the production of painted panels, sculptures, and prints, it also provided the unifying structure necessary for the creation of a tradition. High art prototypes were absorbed by the craft tradition without essentially altering its character.

During the Middle Ages, the Catholic Church was the chief patron of the arts, and later it continued to provide the impetus for much religious folk art. Pilgrimages afforded an important opportunity for cultural interchange in medieval times. Not only were pilgrims exposed to foreign environments on their journeys, they also left a network of cultural landmarks such as chapels and crosses along their routes. Offerings, symbolizing a host of mundane ailments, were customarily brought to the holy shrines by pilgrims hoping for divine aid. Such votives at their simplest might be wax replicas of afflicted parts of the body. More elaborate painted panels traditionally depicted the supplicant in prayer, often side-by-side with a representation of his problem and, in the heavens above, the saint or saints to whom appeal was being made (Figures 6 and 8). Such votive offerings, made in dire need, became proof of a shrine's miraculous efficacy if the supplicant's prayers were answered. Thus the panels were allowed to remain in the churches, often joined by similar images offered in gratitude for assistance rendered.[13]

The sale of votives and religious prints was one of the many practices banned by the Protestant Reformation in the sixteenth century. Such worldly manifestations of God's power, it was held, might too easily detract from the spiritual essence of Christianity. For a time the production of votives all but ceased. However, by the end of the century they had begun to reappear. As the Counter Reformation got under way, the Catholic Church found them to be useful evangelical tools.

Although some supplicants fashioned their own votives, it is likely that most were made by craftsmen who specialized in such work. In France, workshops turned out large numbers using standardized imagery.[14] Elsewhere, votive making was a way for craftsmen in differing fields to supplement their income. This led to the development of such specialties as the iron votives produced by the blacksmiths in alpine Austria (Figure 7).

Religious sentiment also found expression in devotional images intended for display in the home. Other than printmaking, perhaps the most widespread form such expression took was reverse painting on glass. This art originated in Germany in the sixteenth century, where it was employed on a limited scale to reproduce well-known paintings for sale to an upper-class clientele. True to a pattern observed in other branches of European folk art, the high art of one generation became the common art of the next. The heyday of reverse-glass painting did not begin until the eighteenth century, when a network of manufacturing and marketing centers encouraged wide-scale distribution. Beginning in the town of Augsburg, the craft spread through the Black and Bavarian Forests, Silesia, Bohemia, and from there to the Austrian village of Sandl. By the third quarter of the nineteenth century, there were close to twenty workshops in this Austrian district alone. The finished products were sold by peddlers and wholesale merchants throughout the European continent.[15] The discovery of "foreign-looking" glass landscape paintings in England leads to the speculation that the Germans may have produced a secular variant for the Protestant trade.[16] Perhaps inspired by the German example, glass painting became a local craft popular both in Europe and America.

The wholesale production of reverse-glass paintings was an outgrowth of the glass blowing industry and remained tied to it. Frames, which protected the fragile works from breakage, were provided via a mutually beneficial arrangement with the frame manufacturers. The skill and training of the artisans who did the actual painting varied. In Bohemia, the craft was a cottage industry, and often the different tasks were divided among entire families working at home.[17] When the craft was first transplanted to Austria, professional painters were put to work decorating glass. These artists, accustomed to working in other media, had technical difficulties that caused aesthetic imperfections. As the glass painting industry grew, it became more commercialized and consequently less creative.[18]

Reverse-glass painting had been developed as a simple means of copying prints, and prints continued to provide a chief source of imagery. Stock motifs could be easily traced through the glass and then colored with bright primary colors. Sometimes, metallic foil was applied for a mirrorlike or gilded effect (Figure 18).[19] The technique favored a two-dimensional treatment of forms and space. Colors were applied in unshaded blocks, and contours were reduced to simple lines. Often it is possible to discern the outline derived from the original template. Occasionally a peasant motif such as a tulip was brushed in freehand (Figure 16).

Well-known religious paintings dating back to the Middle Ages served as inspiration (Figures 9 and 10). The limited compositional schemes and lack of spatial depth in

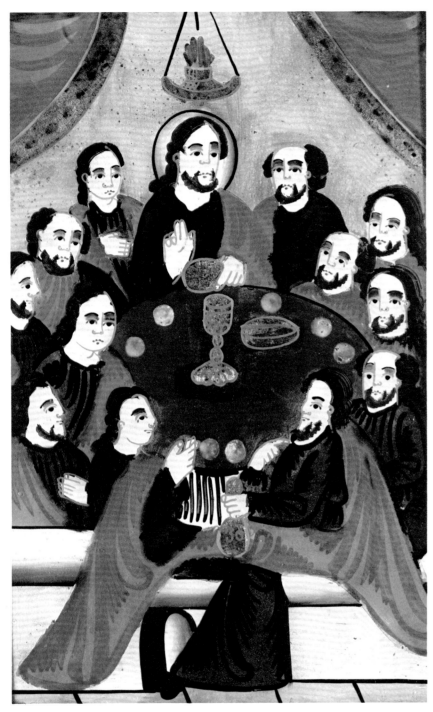

Figure 11. **Anonymous Austrian Artist.** Last Supper. 19th century.

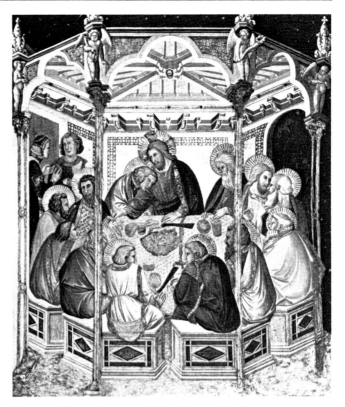

Figure 12. **Pietro Lorenzetti.** Last Supper (detail). 1320 – 40.

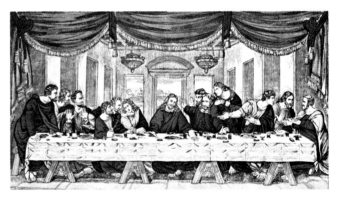

Figure 13. **Anonymous French Artist (after Leonardo da Vinci).** The Last Supper. 1800 – 50.

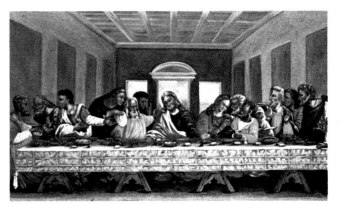

Figure 14. **Anonymous French Artist (after Leonardo da Vinci).** The Last Supper. 1800 – 50.

Figure 15. **Cologne Master.** The Madonna of the Sweet Pea (center panel). 1400–30.

Figure 16. **Anonymous Austrian Artist.** Virgin and Child. 19th century.

the glass paintings suggest that pre-Renaissance formulae remained influential well into the nineteenth century. An Austrian rendition of the Last Supper (Figure 11), for example, relies on a compositional design reminiscent of Lorenzetti's fourteenth-century version (Figure 12). Reduced to a two-dimensional pattern, the composition depends on a complex arrangement of the figures to generate interest. A reverse-glass painting of the same subject from France (Figure 14), where prints of Leonardo da Vinci's famous fresco were readily available (Figure 13), incorporates the Renaissance conception of space.

The tradition of religious art, one of the oldest in Europe, was one of the first to be brought to the New World. The Spanish conquered Mexico in the early sixteenth century and by the seventeenth had established settlements in what is now the United States. As early as 1546, Coronado had made an expedition north of New Spain to New Mexico. He reported back that the territory was little more than a barren wasteland. Nevertheless, the Franciscans, with a missionary zeal excited by the Counter Reformation, set out to claim the souls of the American Indians. In 1610 they established the northern frontier of the

Figure 17. **Anonymous New Mexican Artist.** Our Lady of Carmel. Ca. 1780–90.

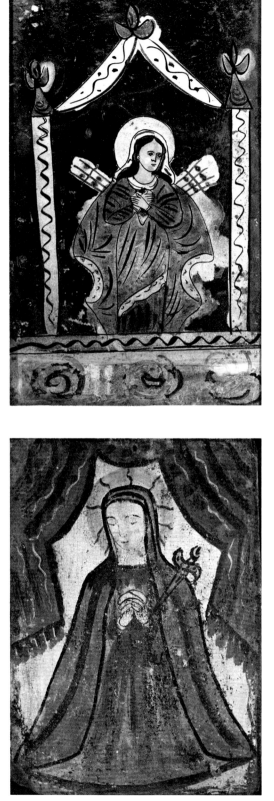

Figure 18.
Anonymous Austrian Artist.
Female Saint. 18th century.

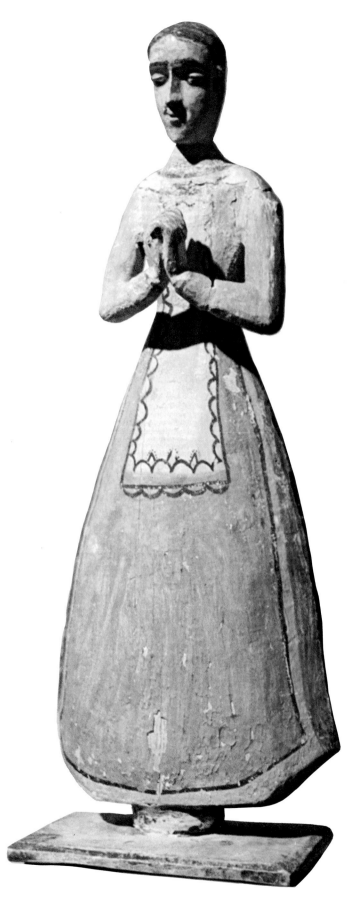

Figure 19.
**Anonymous New Mexican
Artist (style of José Aragón).**
Our Lady of Seven Sorrows.
Ca. 1820–35.

Figure 20. **José Benito Ortega (attributed).**
Our Lady. Late 19th–early 20th century.

Spanish territory at Santa Fe. They held this outpost successfully until 1680, when rebellious Indians destroyed the entire settlement. Undaunted, the Spanish returned in 1693, and by the end of the century the New Mexican territory was secured.

Although votive paintings in the European manner were created in the New World, the most distinctive American contribution to religious folk art was the santo.[20] Santos, holy images, were created for display in both home and church. The largest versions, reredos, were full-scale altarpieces often composed of several panels. The smallest could be carried on one's person. Santos might be either pictorial (retablos) or sculptural (bultos).

After the first flurry of colonization, New Mexico returned to a state of relative isolation. Communication with the Spanish settlements to the south was difficult. As the means of transportation were relatively primitive, only the most essential goods could be shipped north. Therefore, the New Mexican santero (maker of santos) learned to make do with what materials were available. Some of the earliest religious paintings were done on elk, buffalo, and deer hides (Figure 21). Retablos were made from hand-adzed pine panels coated with gesso and painted with water-soluble pigments (Figure 19). It is thought unlikely that oil paints were manufactured in New Mexico. Bultos were carved from a single piece of pine or cottonwood, with appendages pegged into place (Figure 20). Drapery might be added by immersing fabric in gesso and molding it around the wooden figure.[21]

The first religious paintings in New Mexico were created by missionaries as teaching aids. However, not all missionaries were artistically inclined. As the Catholic community grew, they were unable to meet the demand for devotional objects. Early attempts to train native santeros were curtailed by the immigration of Spanish artists who resented the competition. Indians were, however, encouraged to remain on in apprenticeship positions, and thus a class of skilled indigenous craftsmen developed.

Stylistic innovations traveled slowly to the American colonies. The Spanish who settled Mexico were still steeped in medieval traditions. Spain, united with the Low Countries, Austria, and Germany under the rule of the Holy Roman Emperor, favored related forms of aesthetic expression.[22] In the seventeenth century, the Catholic Church turned to the direct emotional appeal of the Baroque style in its battle against the Reformation. The style was adopted wholeheartedly by converts in America, who expanded upon it in ever more eccentric ways throughout the eighteenth century. Not until the 1800s

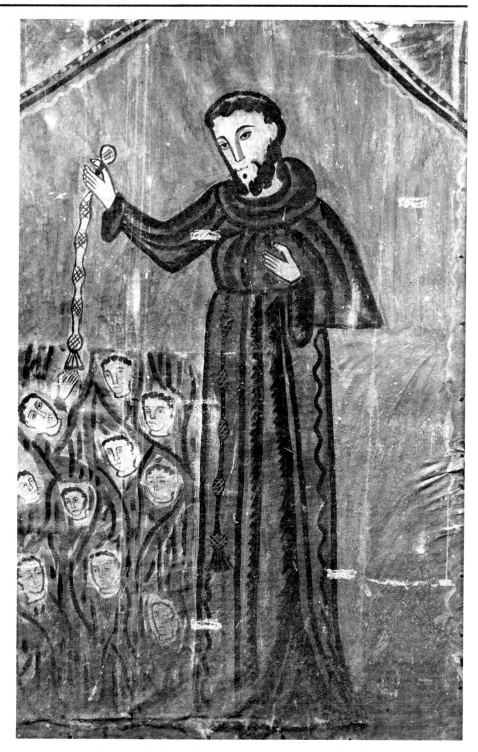

Figure 21. **Molleno.** St. Francis Rescuing the Souls of the Damned. Ca. 1810—20.

could the native style be considered an independent entity. It was then that the religious arts truly flourished in the American Southwest.[23]

As in Europe, printed materials provided the most important source for religious folk art. The Plantin Press in Antwerp supplied most of the illustrated religious texts

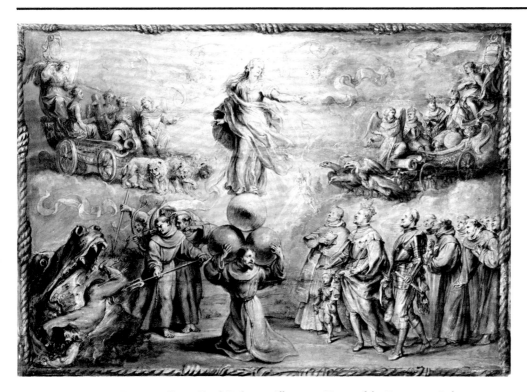

Figure 22. **Peter Paul Rubens.** Allegory in Honor of the Franciscan Order. 1631 — 32.

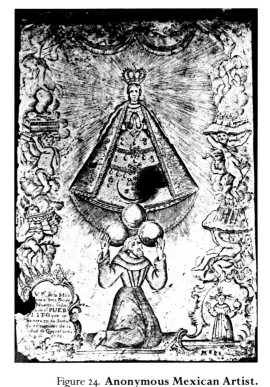

Figure 24. **Anonymous Mexican Artist.**
True Portrait of the Miraculous Image of
Our Lady of the Pueblito. 1776.

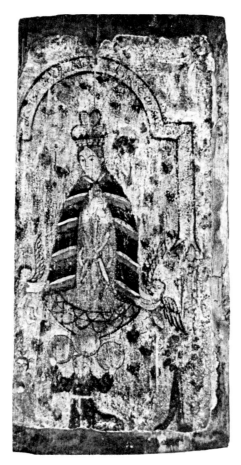

Figure 23. **Anonymous Santero "A. J."**
Our Lady of El Pueblito. Ca. 1820.

sent to the Hispanic colonies. A Flemish influence could also be felt in the religious prints manufactured in Mexico. E. Boyd has traced the transformation of an oil by Rubens into a retablo by the anonymous santero "A. J." Rubens introduced the configuration of a Franciscan father juggling three symbolic globes beneath a vision of the Virgin Mary (Figure 22). The painting inspired the construction of a statue in the Mexican village of El Pueblito. Within a few decades, the village became a holy shrine, attracting hordes of pilgrims. As was customary, prints of the statue were sold as souvenirs or indulgences (Figure 24). Undoubtedly, it was through one of these that "A. J.," working in New Mexico, became familiar with "Our Lady of El Pueblito" (Figure 23). [24]

The iconographic variations available to artists working within the relatively restricted possibilities provided by the Church are demonstrated by the works they produced. The tendency of remoter areas toward simplified imagery reaches an extreme in the almost abstract stylization of the later santos (Plate 3). However, even the most exotic of these creations remains bound to the conventions of the Catholic religion. Confined by strong, long-established formal customs and subservient to the needs of the community, religious painting was little more than an extension of the European crafts tradition. The development of nonacademic painting as an individualized form of expression was actually hindered by the domination of the Catholic Church. [25]

Folk Painting in the United States

It has been said that Switzerland and the United States are the only two countries within the sphere of European culture in which significant traditions of folk painting evolved.[26] In Switzerland, this development occurred in the Alpine region of Appenzell, where concerns centered on the life of the herdsman, his home, and his cattle. Because it is limited both in subject matter and in geographic scope, the phenomenon of Appenzeller painting is less complex than its American counterpart. It is therefore to the latter that we shall now turn our attention.

A direct connection between American nonacademic painting and European folk art was established by immigrants who brought their national customs with them. The first U.S. census in 1790 showed the English to be an overwhelming majority, comprising 60 percent of the population. Therefore, despite the presence of German,[27] Dutch, French, Swedish, and Spanish immigrants in the United States, the dominant cultural influence on both high and folk art was British.

British folk art, like its counterpart on the European continent, was an outgrowth of the medieval guild system. The tradition, not surprisingly, was crafts-oriented, and manifested itself as such when it surfaced in the United States. Shop signs, cigar-store Indians, ships' figureheads and scrimshaw, overmantel paintings and wall stencils are some of the American crafts objects that had British roots. England, however, lacked the strong tradition of folk portraiture that developed in the United States. Perhaps this was due to the small and relatively metropolitan nature of the mother country, which fostered a more pervasive influence of high art forms.[28]

Increasingly influential in both countries were various how-to manuals of different kinds. British instructional texts which found their way to America included *The Graphice or The Most Ancient and Excellent Art of Limning* (1612), *The Artist's Assistant in Drawing, Perspective, Etching, Engraving, Mezzotinto Scraping, Painting on Glass, in Crayons, in Water Colours and on Silks and Satins, the Art of Japanning, etc.* (1750), and *Progressive Lessons* (1824).[29] While some manuals were intended for the professional artist, others, such as *The Ladies Amusement or Whole Art of Japanning* (1760), obviously were not. The latter category covered a host of "amusements" that constituted a rather serious part of a young lady's basic education.

Needlework samplers (Figure 25) were executed by girls of primary school age according to designs derived from books that provided removable patterns.[30] They were embroidered by the earliest settlers in America and continued to be a meaningful component of female training

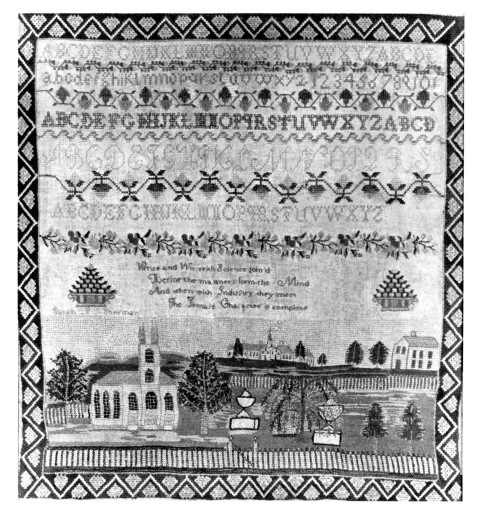

Figure 25. **Sarah P. Sherman.** Mourning Picture with Alphabets and Verse. 19th century.

until the mid-nineteenth century. Seventeenth-century pieces, in England and America alike, were long and narrow, serving as stitchwork glossaries rather than visual statements. In the eighteenth century, the square or rectangular format, which allowed a verse or alphabet to be combined with a decorative border, became more common.[31]

In the nineteenth century, watercolor painting became part of the curriculum for British boys and girls.[32] At female seminaries in the United States, a similar emphasis on painting was introduced. The ubiquitous practice of theorem painting, Chinese in origin, was transmitted to America via England and became a popular pastime. The

Figure 26. **Ammi Phillips.** Portrait of Isaac Hunting. 1829.

artist, unlike the craftsman, was a painter of paintings in the European "easel" tradition. Subjects — portraits, landscapes, interiors, genre or Biblical scenes — were the same as those gracing salons across the Atlantic. American nonacademic art served as a substitute for academic art at a time when most Americans were physically and economically isolated from the realm of European high culture. Folk painting was born of a desire to emulate that culture, and, as such, must be separated from folk crafts which stem from the older guild tradition. Academic motifs were borrowed by both the artisan and the artist. However, whereas the artisan subordinated them to a utilitarian purpose, the artist perceived them in purely pictorial terms.

The American folk painter may be distinguished from the "dabbler" simply by dint of the seriousness with which he or she pursued the profession over a period of years. The amateur, like the professional, copied from painted reproductions of the "masters," popular prints, and the work of academically trained American artists. Whether such copying results in innovation or mere imitation depends on the resources of the artist. Schoolchildren produced their works under the supervision of instructors who guided them in the replication of stereotyped designs well within the means of their limited technical skills. Theorems were simply an impersonal method of achieving the same result. So long as image making remained an "amusement," a token of cultural refinement, there was little chance that amateurs would exceed the limitations of their training. The professional, on the other hand, was forced to overcome these limitations. Not all nonacademic painters were entirely self-taught, but all lacked the sort of rigorous, prolonged training that would have been provided by a European art academy. In all cases it was up to them to complete their haphazard educations on their own. The best were able to extract from academic models those aspects that held personal aesthetic meaning and combine them with gradually acquired technical skills. In this there was a freedom of expression that Europeans would not find until they rebelled against the academies in the late nineteenth century.

The first settlers of what is now the United States, like those who colonized Mexico, were still dominated by medieval traditions. The earliest Colonial portraits, painted in the absence of immediate academic models, made use of rudimentary materials and were relatively two-dimensional in design. The art produced at the Dutch settlement in present-day New York was different from that in New England but hardly more sophisticated. By the

technique was complex: designs derived from prints were broken down into basic formal configurations, which were transferred from tracing paper to stencils. Theoretically, the artist could, by reassembling the stencils and coloring them in, create a facsimile of the original. The painstaking attention given to each aspect of the craft is indicated by the presence of preliminary studies, practice sheets, and color samples in surviving artists' portfolios.[33]

In England, folk works may be characterized as the creations of either "aristocratic dabblers" or professional craftsmen.[34] In the United States a third category arose: that of the professional nonacademic artist. The

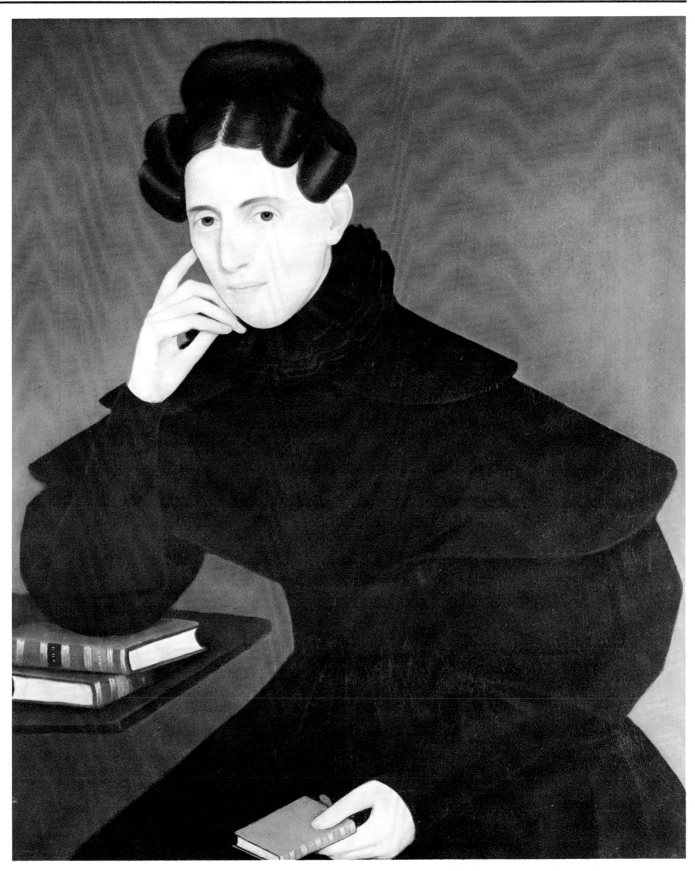

Figure 27. **Ammi Phillips.** Woman in Black Ruffled Dress. Ca. 1837.

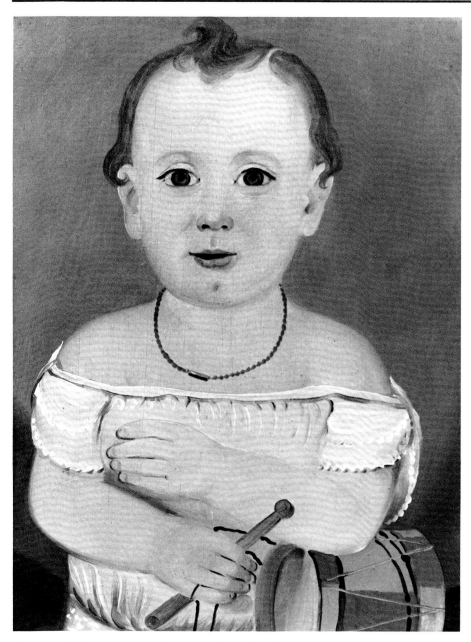

Figure 28. **William Matthew Prior (attributed).** Baby with Drum. Ca. 1850.

mid-eighteenth century a new generation of artists, both native and foreign-born, was creating more realistic work.[35] Advanced ideas of English origin became pervasive, and Dutch influence waned. European artists enjoyed profitable sojourns in the prospering capitals, New York and Boston, and exerted an influence on native American artists who came in contact with them. The British mezzotint was particularly instrumental in transmitting the standard poses and compositions used in portraiture. The portrait, until now the dominant genre, was joined by landscape as a popular art form. A relaxation of strict Puritan doctrine, which labeled all types of more ornamental painting frivolous, has been thought responsible for this change.

It is generally felt that the tradition of nonacademic painting that began in the Colonial era peaked in the first half of the nineteenth century. American painters who came of age during this period, born after the Revolution, had never experienced English rule. The most strenuous years of wilderness-taming were over in the East. There was more money, more leisure time, and consequently more demand for art.

The best-known folk painters of nineteenth-century America are the so-called "limners." "Limner" is thought to be a corruption of "illuminer," a word used to describe the painters of medieval manuscripts. Its expanded usage in eighteenth-century England was therefore confined to the watercolorist.[36] In the United States, however, the term was customarily applied to nonacademic portrait painters, often itinerant, who usually worked in oils. The background and training of the limner varied, but it is more than likely that he viewed his occupation not as an aesthetic calling, but as a source of income. Portrait limning was both prestigious and profitable, as a contemporary account by a disgruntled academician indicates: "You may gain more money [by limning] than you could by any mechanical business, which, you must know, is far more laborious and less genteel and considered. Were I to begin life again, I should not hesitate to follow this plan, that is, to paint portraits cheap and slight, for the mass of folks can't judge the merits of a well finished picture."[37] Portrait painting, then, was a sensible career choice, one made early by many artists and followed without interruption throughout their lives. For others, limning was an outgrowth of a crafts training. Coach painters, sign painters, even house painters turned to it as an additional source of income. When portrait commissions were scarce, they could always fall back on their craft.[38] Limners were trained by other limners, or sometimes they trained for brief periods with

academic painters. When, in the mid-nineteenth century, daguerreotype portraiture made their function obsolete, they turned increasingly to landscape painting or tried to master the new invention.

The theory — advanced when American folk painting was first being rediscovered — that all limners were anonymous was quickly disproven. Anonymity, after all, is relative. The limners certainly knew who they were, and before long scholars did, too. On the basis of stylistic similarities and an occasional signed piece, entire artistic identities have been reconstructed. One of the most intricate bits of detective work was that performed by Lawrence and Barbara Holdridge, assisted by Mary Black, in tracing the career of Ammi Phillips. This team of investigators acquired enough evidence to establish that two seemingly disparate groups of portraits were by Phillips. Having thereby identified a substantial portion of his oeuvre, they were able to flesh out the rest of his development.

In the years since they were rescued from virtual oblivion, the paintings of Ammi Phillips have achieved an astonishing degree of renown, partly because of their distinctive stylization. The artist's first important creative period, perhaps influenced by the portrait painter J. Brown, is in some ways his most beautiful. Dating from 1812 – 1819, these portraits are ethereal visions in delicate pastel shades. In spite of the convincing evidence amassed by Black and the Holdridges, this period remains difficult to reconcile with Phillips's other work. Possibly inspired by the academic painter Ezra Ames, who worked the same territory, Phillips in 1820 embarked on a new style which can more readily be associated with his mature period. Already in evidence here are the somber palette, the delight in intricate lacework, and the massing of block forms which set Phillips apart from his contemporaries.[39]

Woman in Black Ruffled Dress (Figure 27), painted in the mid-1830s, exemplifies Phillips's style at its peak. The contours of the dress have been reduced to geometric forms, which are intermeshed using a sophisticated black-on-black technique. The billows of the sleeves are readily identifiable, yet in silhouette the figure is abstract. A similar effect is achieved with the woman's face and right hand. The thin lips, slightly hooked nose, and piercing eyes convey the flesh-and-blood personality of the sitter, and the positioning of the fingers bespeaks a knowledge of their anatomical structure. But the features rest in a strangely smooth oval, and the hand is disconcertingly flat. A final jarring element is added by the table, which appears to float in midair. The combination of abstraction and

Figure 29. **Prior- Hamblen School.** Portrait of a Woman in a Gray Dress. Mid-19th century.

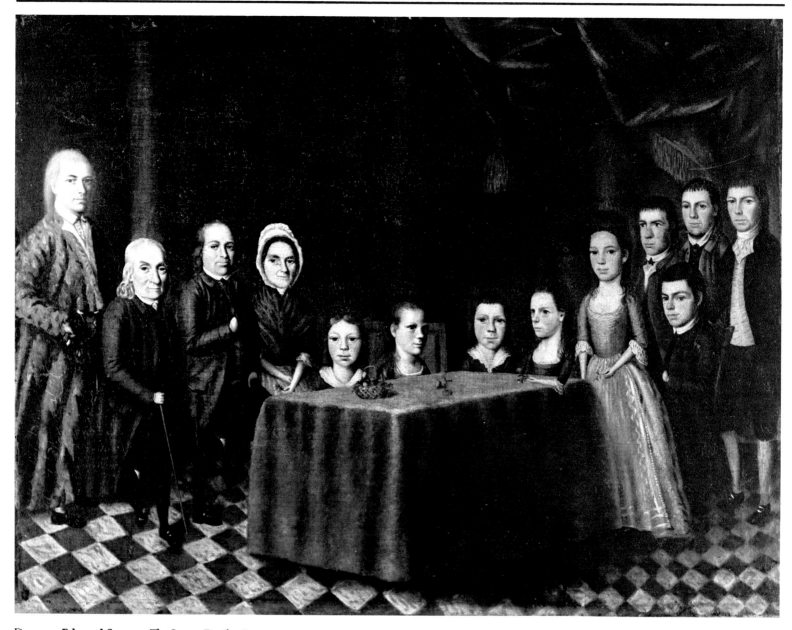

Figure 30. **Edward Savage.** The Savage Family. Ca. 1779.

realism is almost surreal, and the limited palette exploits these contrasts for maximum effect.

From the scant information available, it seems that Phillips was entirely self-taught. Not so his colleague Erastus Salisbury Field, who studied for several months with the noted painter Samuel F. B. Morse in New York City. Even before this brief apprenticeship, Field was painting portraits of remarkable accomplishment. Of particular interest is his use of a greenish underpainting scumbled over with translucent flesh tones to convey facial contours.[40] This method, found also in the work of other limners, indicates the technical sophistication possible even for untrained artists. From Morse, Field appears to have

gleaned a certain facility in handling paint that resulted in broader, less meticulous brushstrokes. In the 1830s, as he traveled through western Massachusetts and Connecticut, he must have encountered the work of Ammi Phillips, one of the most successful limners in the area. His adoption of similar poses suggests that the younger artist was influenced by Phillips.[41]

His *Portrait of Susan Maynard Shearer* (Figure 5) of ca. 1833 reveals the differing degrees of success Field experienced in meeting the requirements of portraiture. Most expertly conceived is the face, which benefits from the deft underpainting in its firm and convincing structure. Less persuasive are the hands, which are presented as solid

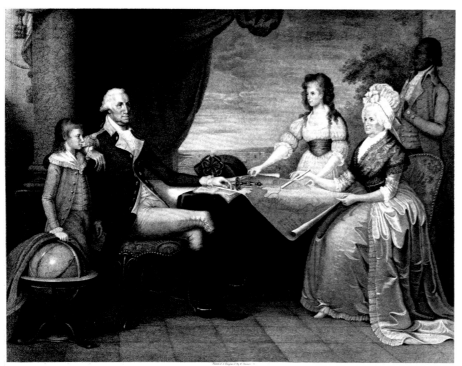

The WASHINGTON FAMILY.
George Washington, his Lady, and her two Grandchildren by the name of Custis

La FAMILLE de WASHINGTON.
George Washington, sa Epouse, et les deux petit enfans de Madame

Figure 31. **Edward Savage.** The Washington Family. 1798.

Figure 33. **Anonymous American Artist.**
The Washington Family. Ca. 1800.

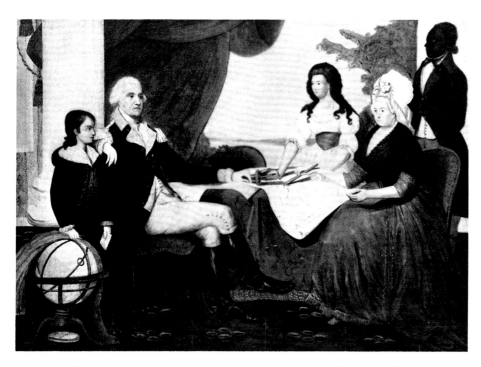

Figure 32. **Anonymous American Artist.** The George Washington Family. Ca. 1800.

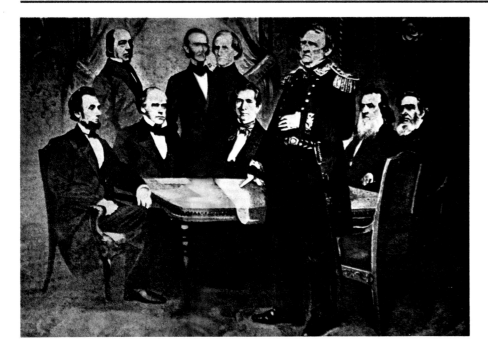

Figure 34. **Mathew Brady.** General Winfield Scott Addressing Lincoln and His Cabinet. Ca. 1860.

masses, the fingers congealed into an undifferentiated whole. Field, in treating large formal configurations such as the dress, has not achieved the aesthetic purity of Phillips, whose abstractions were predicated on an intuitive grasp of basic structures and design.

Field's artistic development led him away from the smooth rendering of his early years to an ever broader, freer approach which has been described as near pointillistic.[42] Unlike Phillips, he seems to have been adversely affected by the advent of the daguerreotype, an invention that was, ironically, promoted by Field's one-time teacher Samuel Morse. That the camera was, as Morse contended, an aid to the portrait painter is indisputable. Phillips, Field, and others used it to eliminate lengthy portrait sittings. But for those who lacked the unshakable clientele of an Ammi Phillips, it also eliminated the market for the comparatively costly oil portrait. Field's use of photography resulted in stiffer portraits generally considered inferior to his former paintings. The scarcity of portraits attributable to the last decades of his life indicates the declining demand for this sort of work.[43] In his later years, Field turned increasingly to landscape, historical, allegorical, and religious subjects (Plate 5). Many of these paintings leaned heavily on another nineteenth-century invention that had a great impact on the nonacademic painter: the chromolithograph.

The confluence of outside influences in the work of the limner may be illustrated by the case of Joseph Whiting Stock, whose diary provides valuable source material.

After a childhood accident made a career of physical labor impossible, the boy's doctor suggested that he learn to paint. Stock's training was of the most rudimentary sort. Lessons from a student of Chester Harding brought the precepts of academic portraiture to him thirdhand. When the lessons were done, Stock honed his skills by copying pictures of famous figures such as Andrew Jackson, Napoleon, and Sir Walter Scott. Later, when the introduction of photography threatened his livelihood, he entered into an on-again-off-again partnership with a daguerreotype artist.[44]

Stock's *Portrait of Mary Abba Woodworth* (Plate 6), painted at the beginning of his professional career, indicates the results of his cursory education. The cat and the sofa in the background are crudely rendered, while the artist concentrates his energies on the portrait proper. Despite evident difficulty achieving an anatomical likeness of the hands and limbs (often a problem for the self-taught), the arms are disposed in a graceful pattern. The stylization of the "real" flowers carried by the girl is boldly set off by the floral pattern of the rug. The formal configuration of the cat, coiled into an upside-down question mark, is echoed by the scrolls of the sofa. Regardless of its occasional awkwardness, the painting achieves a harmonious balance of the disparate elements.

The varying degrees of technical expertise applied to the different segments of Stock's portrait are typical of the nonacademic painter. As one British observer pointed out in an 1876 treatise on architecture, "The majority of men who can draw the figure tolerably well can draw nothing else correctly ... the representation by our best portrait painters of the accessories which they introduce into their pictures, especially of architectural details, is almost without exception ludicrously inaccurate."[45] One cannot expect the American nonacademic to have mastered what the English artist, with access to all the academies of Europe, could not. The contrast between figure and furnishings alluded to in Stock's painting becomes explicit in the anonymous *Greek Revival Interior* (Plate 4).

Phillips, Field, and Stock were "fine" artists from start to finish, though it is possible they may have occasionally received assignments in a more utilitarian vein.[46] William Matthew Prior, willing to take on commercial work in addition to both academic and nonacademic portraiture, presents another variation on the limner career. His multifaceted undertakings are documented by the advertisements he placed in local newspapers. In 1827 he billed himself as a specialist in "ornamental painting,...bronzing, oil guilding and varnishing." From this he advanced to sign

painting and mechanical rendering, and by 1828 he was hawking his portraits.

From the various ads he ran in the ensuing years, one line has consistently fascinated students of his work: "Persons wishing for a flat picture can have a likeness without shade or shadow at one quarter price."[47] The suggestion that a painter might have been able to make a conscious decision to paint academic or folk, that he might turn his abilities on and off at will, has startling implications. Corollary to this is the oft-debated canard regarding the use of "stock" bodies. This hypothesis — that limners whiled away the idle winter months by painting headless bodies which could later be topped with individual faces — has been largely disproven.[48] However, in the case of Prior, the unmistakable similarity of the "flat" portraits and the known fact that he carried stretched canvases with him on his journeys tend to lend some credence to the theory.[49]

The facility with which Prior endeavored to slip from academic to nonacademic modes seems to have undermined the efficacy of both. Prior lacked the polish to be a truly accomplished painter in the academic tradition. For his nonacademic portraits he invented a highly schematized approach (Figures 28 and 29), but the endless repetition of motifs eventually squelched the originality of the invention. The most significant thing about Prior is his self-conscious creation of a deliberately nonacademic style. In the twentieth century, other artists, prompted by the popularity of naïve painting, would attempt to do the same thing. Both their work and Prior's has an artificiality that sets it apart from the achievements of other nonacademic painters.

Prior's alternation of academic and nonacademic styles indicates the extent to which the two were intertwined. There were always artists who, given time, crossed the threshold from nonacademic to academic. Benjamin West was one of the first and best known to do so. Edward Savage was another. Savage's group portrait of his family (Figure 30), painted before his twentieth birthday, is the work of an immature artist struggling to achieve an academic effect. Savage tried to teach himself by copying the paintings of John Singleton Copley, but in 1791 he set sail for England, where he could receive more structured training. Having returned from England skilled in the techniques of mezzotint and stipple engraving as well as painting, he executed an engraved copy of his famous portrait of *The Washington Family* (Figure 31). Prints of George Washington were extremely popular in the years following the Revolution, when the recent memory of his

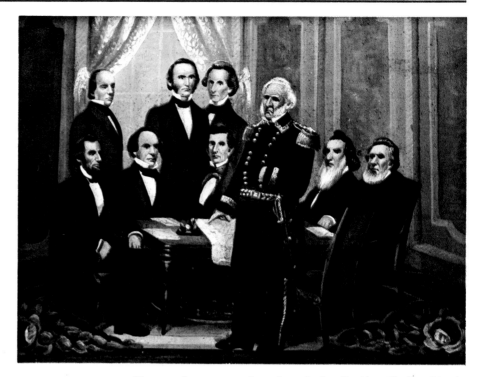

Figure 35. **Anonymous American Artist.** President Abraham Lincoln and His First Cabinet. Ca. 1860.

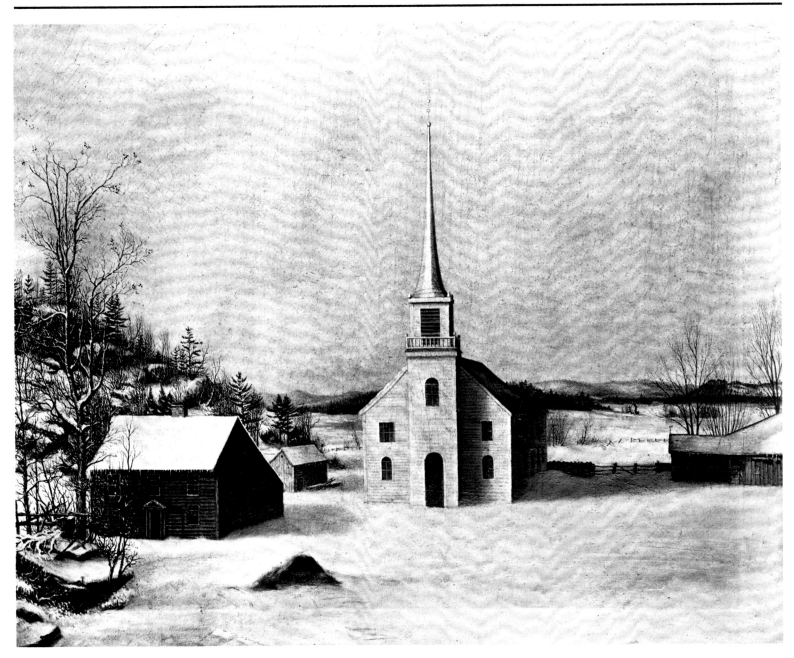

Figure 36. **George Henry Durrie (attributed).** Church, Westfield Farms. Ca. 1850-1900.

role in founding the nation excited general adulation. At least two anonymous painted copies of the Savage engraving are known to exist. The first attempts a verbatim replication of the engraving, and in a somewhat simplified fashion, achieves it (Figure 32). The artist, however, could not resist adding a floral pattern to the rug and tablecloth. The second copy is far more whimsical (Figure 33). This painter does not stop at embellishing the rug. In a wild flight of fancy (the painting is 84¾ inches high) he or she imagines the conventional drapery of the engraving as a soaring theatrical curtain. At the same time, the scene has become much cozier. Gone are the officious servant in the background and the general's sword. The style of dress is more casual, the daughter's coif has been transformed into a loose cascade of hair, the mother's elegant hat has become an ordinary bonnet. Thus the work of an academically trained painter, himself once a "primitive," has come full circle to inspire nonacademic art.

Lincoln, both in his day and after, also enjoyed widespread public admiration and was a popular subject for the folk artist. *President Abraham Lincoln's Funeral Procession,* the only known work by an artist who signed himself S. F. Milton, displays the somber strength possible in the best nonacademic paintings (Plate 7). Lincoln lived in the age of photography, a development not lost on the anonymous soldier who painted *President Abraham Lincoln and His First Cabinet* (Figure 35). The artist copied a photograph by Mathew Brady (Figure 34), which he may have seen reproduced in one of the illustrated weeklies then gaining prominence. Ironically, the photograph itself was a composite, a device used by Brady to creatively expand the inherent limitations of journalistic photography. Thus Brady, striving for a more artistic effect, influenced a nonacademic artist striving for realism.

By correlating nonacademic art with its printed or photographic sources, it is possible to achieve a greater understanding of its relationship to academic painting. The folk artist did not invent; he or she improvised. Personal expression was achieved by the adaptation of prevailing academic forms and the refinement of technical abilities. Perhaps the greatest of all the nineteenth-century nonacademics, Edward Hicks, was the one who attained the most harmonious synthesis of these elements. Hicks was an American and a Quaker, and he invested his *Peaceable Kingdom*s with the full strength of his religious and nationalistic sentiment. The paintings, of which some sixty are currently thought to exist, illustrate Isaiah's prophecy that "the wolf also shall dwell with the lamb, and the leopard shall lie down with the kid...and a little child shall

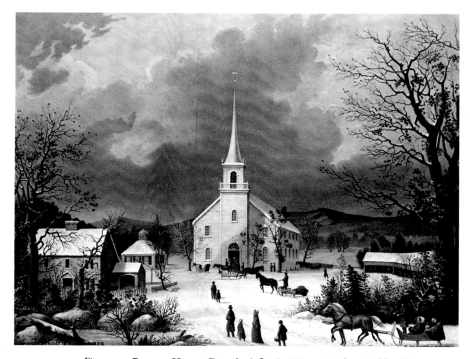

Figure 37. **George Henry Durrie (after).** Winter Sunday in Olden Times. 1875.

lead them." Because, to Hicks, the United States represented the full promise and realization of the prophecy, he added in the background a depiction of William Penn negotiating his peace with the Indians.[50]

Hicks apprenticed with a coachmaker, and when he set up his own shop he was competent to paint not only coaches, but signs, furniture, fireboards, and clocks. His earliest known *Kingdom*, dating from April, 1826 (Plate 8), demonstrates the technical prowess he had garnered from his crafts training. By the time he completed his last renditions of the subject, his skills had grown to such an extent as to equal or surpass those of most academic painters (Plate 9).

Eleanore Price Mather has shown that each of the separate elements which comprise the *Kingdom*s was copied from a printed source. The initial configuration of the child and animals was taken from Richard Westhall's engraving *The Peaceable Kingdom of the Branch.* The natural bridge which appears in the background of the early *Kingdom*s was derived from a map of North America. A later background depicting the Delaware Water Gap came from an engraving by Asher B. Durand. The Penn treaty scene was copied from a print of Benjamin West's painting of the same subject.[51]

Here, then, is a paradox: a self-taught artist with academic skills emulates academic images yet creates nonacademic art. The key to this mystery lies in the fact that it was never Hicks's intention to create an academic painting, but rather to give form to his vision. To this end he applied his skills as a craftsman, which, with practice,

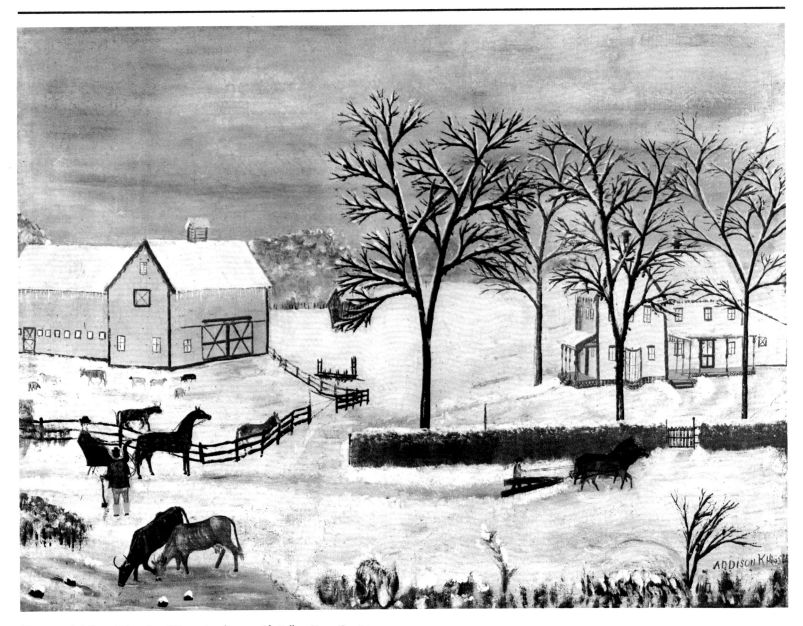

Figure 38. **Addison Kingsley.** Winter Landscape with Yellow Barn. Ca. 1860.

became highly refined. To this end, and with these skills, he transformed the printed images. He recombined them to create his own composition, improvised color, translated their stippled and incised lines into brushwork, and, in time, modified their pictorial makeup. From his first *Kingdom* to the last, he created masterpieces that outshine in freshness and in strength the academic works from which they are derived.

As the nineteenth century advanced, the opportunities for painters to acquire direct exposure to academic methods multiplied. Lithography, photography, mechanized printing, and illustrated periodicals increased the availabiliy of ready-made images. The establishment of

museums improved public access to original art. From here it was only a few short steps to the proliferation of popular art on a mass scale.

The chromolithograph was perhaps the most common way in which manufactured art invaded the average home. Early lithographs, like engravings, had to be colored by hand. Only in the 1840s and '50s did the technology for printing in color become commercially viable. The best-known publisher of colored lithographs, Currier and Ives, dates to 1857, though Currier had been in business by himself since 1834. It was not until after the Civil War, however, that the "chromo boom" reached its zenith.[52] Low prices and mass marketing schemes helped Currier and Ives come close to realizing their goals of producing

"the cheapest and most popular prints in the world."[53]

George Henry Durrie was one of the contributors to this new art boom. He began his career according to the familiar pattern. At nineteen he hit the road in search of portrait commissions. He studied with Nathaniel Jocelyn, a second-rate academic painter and colleague of Samuel Morse. Durrie, in his hunger for work, was willing to do fireboards, window shades, and most likely any other sort of decorative assignment. Like many others, he was curious about the benefits that might be obtained from the daguerreotype as an aid to portrait painting. Like many, he was all but driven out of business by it.[54]

But Durrie was part of a younger generation than Phillips or Field and was able to turn the changing aesthetic climate to his advantage. Like other portrait painters, he had always dabbled in landscape, but now he saw that landscapes were actually acquiring more prestige than portraits. To develop his landscape style, Durrie turned neither to prints nor to the efforts of limners like himself. Instead, he took as models accomplished members of the indigenous landscape school that had arisen in the first part of the century: Thomas Cole, William Sidney Mount, and Frederic Church. His forte became the New England snowscape, a subject heretofore neglected by American artists.[55]

In 1857, Durrie, feeling he was ready for bigger things, moved to New York. His reception there was less than encouraging, though he did attract the attention of Currier and Ives. The largely self-taught painter failed to make the leap into academia only to reach undreamed-of popularity through lithographic reproductions of his work. In all, Currier and Ives produced prints of ten of his paintings.[56] To a public traumatized by the effects of industrialization, the Durrie prints provided a vision of a happier, more peaceful time. His New England scenes dwelt on the pleasanter aspects of farm life. His style, though accomplished, had a reassuring touch of folksiness.

Lithographic reproductions provided a new source of inspiration for the folk painter. In Addison Kingsley's *Winter Landscape with Yellow Barn* (Figure 38), we see the sort of New England scene popularized by Durrie. Though it cannot be considered a direct copy, the pairing of a farmhouse and barn flanking an open central expanse was a compositional scheme favored by Durrie. *Church, Westfield Farms* (Figure 36), once thought to be a study for Durrie's *Going to Church*, is now considered an anonymous copy of one of his lithographs (Figure 37).[57] Durrie's most famous print, *Home to Thanksgiving* (Figure 39), was copied by Grandma Moses in the 1930s (Figure 40).

Figure 39. **George Henry Durrie (after).** Home to Thanksgiving. 1867.

Figure 40. **Anna Mary Robertson Moses.** Home for Thanksgiving. Before 1940.

Figure 41. **Anna Mary Robertson Moses.** The Spring in Evening. 1947.

Folk Art
in Modern
Times

In the nineteenth century, European folk art, encouraged by growing nationalistic pride and the same affluence that prompted the flowering of American folk art, spent itself in a last burst of glory. Then the modern age arrived. Those communities that had managed, through isolation, to develop relatively autonomous folk styles were no longer isolated. Regardless of their relative isolation, the death blow to crafts-oriented communities was dealt by the competition of cheap, mass-produced goods. In England, in Austria, and in America, artisans and intellectuals tried to establish new crafts movements to combat the dread impact of industrialization, but the cost of labor and the cost of materials were astronomical. Their simple crafts for the simple man could be bought only by the rich. It was too late.

Intellectual appreciation of the craft tradition had developed gradually in the nineteenth century, stimulated by Romanticism, nationalism, and industrialization. It is significant that the trend began with a revived interest in medieval art, which, after all, had been the root of folk culture. In 1797, Wilhelm Heinrich Wackenroder published *Effusions of an Art-Loving Monk,* a text that established some of the precepts for the nascent Romantic movement. The exalted unity of art, religion, and pure craft achieved in the Middle Ages became a new aesthetic goal. In England, related sentiments were voiced by John Ruskin some fifty years later. The carvings of the medieval cathedral, he wrote, "are signs of the life and liberty of every workman who struck the stone; a freedom of thought, and rank in scale of being, such as no laws, no charters, no charities can secure; but which it must be the first aim of all Europe at this day to regain for her children."[58] In Ruskin's statement we see the religious attitude of Wackenroder transformed into a social one. Industrialization was revamping the character of European society. Laws, charters, and charities were no substitute for the perceived loss of human dignity.

The age of exploration had stimulated interest in the cultural curiosities of other lands. Now, suddenly, an interest in heretofore ignored indigenous cultures arose. The French, realizing that their postrevolutionary political structure threatened to eradicate existing folk cultures, set about systematically documenting them. Nationalism, too, was a factor in stimulating interest in native art forms. The search for a national identity in Germany led, naturally, to the search for a national culture, an art "rooted in the soil of the fatherland," as one art historian has put it.[59] By the 1890s this vague yearning for a *Volkskunst* had begun to focus on what is today considered folk art: that wide range of creations, neither medieval nor modern, which had previously existed outside the pale of academic discussion.

The student of folk art was not necessarily an art historian. The new field had broad applications for the sociologist, anthropologist, musicologist, linguist ... in short, for all those concerned with the myriad branches of culture. In fact, folk art was brought into the realm of art history not by art historians, but by artists.

It began with a burgeoning interest in the art of non-Western cultures: the Japanese prints favored by the Impressionists; the Tahitian paradise of Gauguin; and the African carvings that fascinated Picasso, Derain, and Matisse. This was an art truly primitive to European eyes, an art untouched by the blessings and curses of Western culture. For Gauguin, the primitive came to represent both a literal and a figurative escape from a society in which "everything is putrified, even the men, even the arts."[60] To combat mechanization, he sought a return to an aesthetic essence, which he felt might survive not only in the inhabitants of uncorrupted lands, but in the eternal child in every man. "I think that man has certain moments of playfulness, and infantile things, far from being injurious to his serious work, endow it with grace, gaiety, and naïveté."[61]

The longing for the spiritual redemption of modern culture through the reclamation of some essential innocence found concrete expression in an attack on the art academy. "The academy is the surest means...of ruining... the force of the child," wrote Kandinsky in 1912. "Even the very great, strong talent is more or less held back in this respect by the academy. The weaker talents go to ruin by the hundreds. An academically educated person of average talent distinguishes himself by having learned the practical-purposeful and by having lost the ability to hear the inner resonance. Such a person will deliver a 'correct' drawing which is dead. If a person who has not acquired schooling — and thus is free of objective artistic knowledge — paints something, the result will never be an empty pretense."[62]

The search for nonacademic art forms spread from Europe to the United States. Holger Cahill wrote of American folk art that

the discoverers of its aesthetic quality were the pioneers of modern art who began coming back to this country from France about 1910. These artists were in revolt against the naturalistic and impressionistic tendencies of the 19th century, and their emphasis upon a return to the sources of tradition had given them an interest in primitive and naïve art. They first turned to the productions of the American aborigines which they found

Figure 42. **Dominique Lagru.** Spring. 1952.

in the natural history museums. There were few pieces of American folk art in public collections at that time, and these were mostly in the museums of historical societies where they were valued for their relationship to local history or simply as curiosities. The cult of Americana had begun, but it centered about the crafts of the silversmith, the potter, and the furniture maker, and, so far as the fine arts are concerned, in the work of painters like Copley and Stuart. About 1920, artists rummaging through antique shops and farmers' attics for old American furniture came across pictures which arrested their attention. Most of these pictures were merely quaint, but some of them had aesthetic value of a high order, and all of them had a quality which gave them a certain kinship with modern art.[63]

But wherein did this kinship lie? The answer was to be found in the nature of nonacademic realism. Folk artists, limners, naïves were all striving for verisimilitude in their work but failing to achieve it, at least according to academic standards. By academic standards their work was unacceptable, and only when academic standards toppled could it be appreciated at all. The tradition of realism had come to an end, and now the notion that art could ever have presumed to approximate reality seemed preposterous. "They speak of naturalism in opposition to modern painting," wrote Picasso. "I would like to know if anyone has ever seen a natural work of art. Nature and art, being two different things, cannot be the same thing. Through art we express our conception of what nature is not."[64]

Kandinsky felt that art could be reduced to two basic impulses. "The forms for embodiment, which are extracted from the storeroom of matter by the spirit, can easily be arranged between two poles...: 1. the great abstraction; 2. the great realism." These two absolutes, which might also be characterized as the aesthetic and the objective, had existed together in harmony, the one serving the other, in academic art. Now, however, such harmony was no longer possible. Abstraction and realism, divorced from each other, had become "two roads which lead finally to one goal." That goal, which Kandinsky dubbed "the inner resonance of the thing," might be revealed by exposing its abstract essence or, alternatively, by stripping reality of all artifice.[65] If he, Kandinsky, were pursuing the former approach, Henri Rousseau could be considered a master of the latter. Thus Kandinsky gave credence to Rousseau's guileless self-appraisal, so often mocked, that he was "one of our best realistic painters."[66]

Henri Rousseau

Figure 43. **Henri Rousseau.** Study for Notre Dame. 1909.

Regardless of whether one takes an historical or an aesthetic viewpoint, the work of Henri Rousseau must be considered pivotal in the study of nonacademic art. As one writer put it, "basically speaking, 'naïve art of yesterday' means nothing other than naïve art before Rousseau."[67] And, one might add, "naïve art of today" means nothing more than naïve art after Rousseau. Rousseau's achievement bridges the gap between the nineteenth century and the twentieth, between the death of academic art and the birth of modern art. Rousseau was the first self-taught painter to be accorded the status of a true artist, and he is the painter for whom the term "naïve" was coined. Indeed, he has become such a legend in the lore of nonacademic art that his true personality has been virtually obscured.

Rousseau's biography is a mixture of bare facts, speculation, and anecdotes. He was born in Laval, France, the son of a tinsmith. He married a woman, Clémence Boitard, whom he supposedly loved very much; but then, he loved most women very much. During his stint in the army, it was said, he traveled to Mexico, and later, in a heroic act of bravery, saved the town of Dreux from destruction by fire. No record of either escapade was ever found. He settled in Paris and obtained a post with the municipal toll service as a tax collector. (He was never, as his nickname would have it, a customs official or *douanier.*) It was reported that the man's superstitious gullibility prompted his coworkers to tease him by suspending a fake "ghost" on strings outside his post. But as Rousseau doffed his hat and asked the "ghost" if he would like a drink, it must be asked, Who was teasing whom? In 1885, after the death of his wife, Rousseau retired on a modest pension. That same year he exhibited at the official Salon des Champs Elysées, where his paintings were slashed. The following year he showed with the more progressive Societé des Artistes Indépendants, along with Seurat, Redon, and Signac. In the 1890s, Rousseau met Alfred Jarry, author of *Ubu Roi* and a fellow native of Laval. There has been much speculation as to whether the two could have known each other in Laval or run into each other in the Paris neighborhood in which they both lived for a period. They met, as legend has it, before one of Rousseau's paintings at the Indépendants.

Whatever the circumstances of their meeting, Jarry was Rousseau's first acquaintance in the avant-garde cultural world. With this encounter begins the series of anecdotes that purport to convey the persona of the painter. Rousseau had the misfortune (and good sense) to take himself seriously before anyone else did. This faith in his

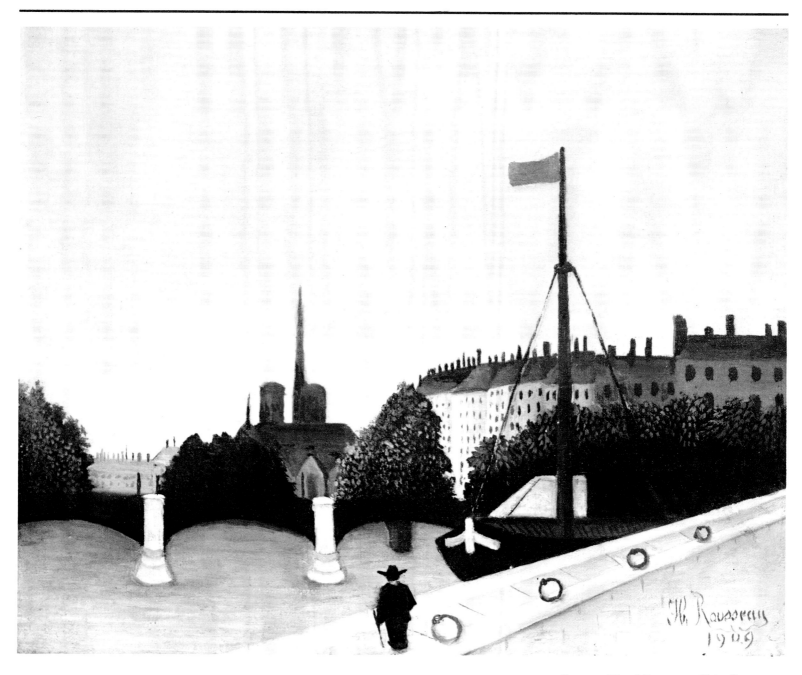

Figure 44. **Henri Rousseau.** Notre Dame. 1909.

own worth was the butt of endless jokes. He would be made to believe that he had received an important award, or a luncheon invitation from the President, or a visit from the famous painter Puvis de Chavannes. What made it all so terribly funny was that the poor little man actually believed he had a right to expect such accolades. Jarry, the artist's first supporter, praised Rousseau and promoted him, and had him paint his portrait. But when he tired of the portrait, he burned it or he cut it up, or, as one story has it, he used the face for target practice.

Rousseau was derided by the press, even as he began, gradually, to count more artists among his friends. In 1905 he exhibited at the controversial Salon d'Automne with the Fauves, including Matisse, Derain, Braque, Rouault, and Dufy. Such notables as Apollinaire, Delaunay, Picasso, Braque, and Brancusi were among the guests at his Saturday night soirées. The French art dealer Ambroise Vollard was beginning to buy his paintings, as was the German Wilhelm Uhde. Yet still he did not earn enough to relieve him of his poverty. And though he was befriended and

feted, the note of mockery remained. At best, the artists echoed the attitude of Degas, who, disgusted with the endless theoretical squabbling at the Indépendants, turned to a painting by Rousseau and said, "Why shouldn't that be the painter of the future?"[68] They entertained the idea as the most outrageous possibility open to them, but they did not seriously believe it.

It can never be truly known just how naïve Rousseau really was, for in all the stories about him the bias of the teller is palpable. What was he really thinking? "He generally acquiesced to everything people told him," recalled Picasso's lover at the time, Fernande Olivier, "but one had the feeling that he held back and did not dare say what he thought."[69] He was highly aware of the derision heaped upon him by the press, for he kept voluminous scrapbooks. He was also aware that other people considered him naïve. "If I have kept my naïveté," he wrote one critic, "it is because M. Gérôme, who was a professor at the Ecole des Beaux Arts, and M. Clément, director of the Ecole des Beaux Arts at Lyon, always told me to do so. In the future you will not find this amazing. Also I have been told that I do not belong to this century. You must agree that I cannot now change the style that I acquired by steady work."[70] It is many years since Rousseau wrote those words, yet the sense of amazement persists. The last thing people want to believe is that Rousseau was a gifted artist who knew exactly what he was doing.

Rousseau devoted himself to his art as thoroughly as any trained artist. The year before his retirement he applied to the Louvre for permission to copy the museum's masterworks. He made faithful pilgrimages to the Jardin des Plantes to sketch from nature. He was not a modernist. He really did admire such painters as Gérôme, Clément, and Bouguereau. It would have pleased him inordinately to be admitted to their ranks. His oft-repeated remark, when confronted by Cézanne's paintings, that he would like to "finish them," may be taken as a sign of his love for academic polish. One must keep in mind, before overemphasizing the originality of Rousseau's exotic landscapes, that similar subject matter had long been popular with the academic painters he admired.[71] He drew inspiration from all the sources available to him, including cheap prints and photographs. He was trying to capture a very personal and precise vision of the world, even though he had the technical ability to fall in with a more conventional artistic group. As Daniel Catton Rich has demonstrated, Rousseau's preliminary oil sketches (Figure 43) could have passed as Post-Impressionist paintings in the manner of Sisley and Pissarro.[72] He chose to "finish" them, and so is judged a primitive (Figure 44).

"I hope you are going to employ your literary talents to avenge me for all the insults I have received," Rousseau wrote Apollinaire shortly before his death.[73] Apollinaire, who when Rousseau was painting his portrait often neglected to show up for sittings, did not deny this last request. Apollinaire, Kandinsky, Picasso, Uhde — there were suddenly more than enough people ready to praise the "Douanier." Hardly a month after Rousseau's death, the American artist Max Weber, who had brought back several canvases from a recent trip to Paris, arranged a memorial exhibition at Alfred Stieglitz's gallery, 291.[74] A similar Rousseau memorial was held in the Salon des Indépendants. "What positive qualities he had!" exclaimed Apollinaire in reviewing the French show. "It is most significant that the young artists were sensitive to just these qualities …. The Douanier went to the very end in his work, something very rare today. His paintings were made without method, systems, or mannerisms. From this comes the variety of his work. He did not distrust his imagination any more than he did his hand. From this came the grace and richness of his decorative compositions."[75]

Hand-in-hand with growing appreciation of Rousseau's artistic achievement came an idealization of his naïveté. During his life, that supposed naïveté had been a source of ridicule. Now it was a source of admiration. "Rousseau saw the world through the eyes of a wide-eyed child," gushed Uhde. "To most adults, an event, scene, vista or whatnot arouses its set responses. These responses will vary from person to person, but are generally explicable…. To Rousseau, however, life was ever a new experience, mysterious and inexplicable. Beneath the look of things, he felt, lay an inner and arcane essence."[76] The legend of Rousseau, his lack of training, his ingenuousness, became inextricably bound up with his art itself. We can never know whether Rousseau would have lost his genius had he received a formal art education. What became significant was that he kept it without one. For the theorists and practitioners of the avant-garde at this crucial point in its early history, the principle behind Rousseau's achievement was as important as its aesthetic merits. As one writer put it, Rousseau was an "object lesson for modern art."[77]

It was not long before a market developed for Rousseau's paintings. After the First World War, Uhde noted, "Dealers and collectors alike, excited by the publication of

high-priced monographs, were falling over one another to buy Rousseaus."[78] There was a pronounced change in the cultural climate after the war. What had once been considered shocking was now acceptable; what had once been considered naïve (in a pejorative sense) was now, so to speak, sophisticated. The founding of New York's Museum of Modern Art in 1929 was an important step not only in promulgating the concepts of the avant-garde, but in furthering nonacademic art. The year 1932 saw one of the first major exhibitions of American folk art, *The Art of the Common Man,* as it was called. In 1938, this was followed by a survey of modern European and American primitives, *Masters of Popular Painting.* Four years later, a Rousseau retrospective was launched. The foreword to the catalogue for that show stated, "Aside from Germany, where [Rousseau] was quickly appreciated, no country, not even his own, has responded so warmly as the U.S. to his sincere and unassuming art."[79] However, when his painting *The Snake Charmer* was hung in the Louvre, it could not be denied that he was ranked with the great masters in France as well.

After Rousseau's apotheosis, it was natural that there should develop a heightened receptivity to contemporary untrained artists. Furthermore, they made good news copy. What could be more appealing than a common house painter, John Kane, "crashing" the Carnegie International? Who could resist that painting grandmother, Anna Mary Robertson Moses? In Europe, Uhde "discovered" a group he called "Painters of the Sacred Heart." Of their art he said, "Ecstasy and devotion are its earmarks." Of the painters, he said they "painted what their hearts, rather than tradition or teachers, taught them to paint."[80] But, as one cynic observed, it takes more than a sacred heart to be a good artist.[81]

The attributes of the artists who were "taken up" in the decades after Rousseau's death varied greatly. Some were city dwellers: Vivin, like Rousseau, was a retired civil servant; Hirshfield, a garment manufacturer; Kane, a jack-of-all-trades in the construction industry. Others had a rural background, like the farmwife Grandma Moses, the gardener Bauchant, the shepherd Lagru. Two — Pickett and Bombois — had a circus or carnival background. None dreamed that painting could provide him or her with an adequate income, and all, therefore, sought other ways to make ends meet.

The painters in this group were handicapped from the start by seemingly hopeless odds of ever "making it" as

Figure 45. **Henri Rousseau.** Rainy Morning. Ca. 1886.

artists. Few had more than a rudimentary education of any kind, let alone formal art training. Each was born in the last half of the nineteenth century, before the ascendancy of the modern naïve artist, and after the heyday of the premodern folk artist. The advent of photography and lithography ensured that they could not make a living serving the aesthetic needs of the so-called "common" folk. Yet the acceptance of naïve art by the sophisticated was not something they could have foreseen. Nonetheless, these people counted in their numbers the first self-taught artists ever to receive international acclaim in their own lifetimes. Theirs was a watershed generation: some said they were the last true naïves; others said they were the first false ones.

In the Footsteps of Rousseau: The French Naïves

Figure 46. **Louis Vivin.** The Gate of St. Denis, Paris. Ca. 1935.

Uhde's Sacred Heart group included Henri Rousseau, Louis Vivin, Camille Bombois, André Bauchant, and Séraphine Louis. Rousseau, the progenitor of the group, had been dead many years before the other four were discovered. Still, Uhde saw in the others a "simplicity and self-dedication" akin to that of the Douanier.[82]

Vivin lived in a fifth-floor walk-up in a run-down Paris neighborhood near Montmartre. He spent his life working for the French postal service, traveling across the country in a windowless railway car. "One night," as Uhde tells it, "he had a vision: Meissonnier appeared in a dream and told him that he could be a great artist if he tried."[83] Fortunately for Vivin, he had his vision at a time when art critics were inclined to take the ambitions of retired postal inspectors seriously. His proximity to Montmartre was also fortuitous, for here even works in a pedestrian gallery might be noticed by the likes of Uhde. Vivin succeeded in getting just such a gallery to take some of his paintings, and that was just what happened.

Perhaps during his long, dim journeys Vivin had tried to imagine what lay outside his train. Now, copying from postcards, photographs, and prints, he painted images of far-off places and scenic views of Paris (Figure 46). Though his oeuvre encompasses a broad range of subject types from still life to landscape, he is probably best known for his cityscapes. Vivin was the originator of an "every brick" sort of realism that would later be emulated by other, less original naïves. His, however, was a genuine fascination with the geometry of space. Because, perhaps, he was copying at his leisure from photographs of man-made objects, he became concerned with precisely delineating their structures. Self-taught artists are often fondly chided for the lack of perspective in their work, but many have invented equally effective nonacademic methods for conveying distance. Vivin knew that diagonal lines could be used to define receding objects, and he had also noticed that these lines tended to converge in the distance. What he lacked was the awareness of a single vanishing point that would give dimensional unity to an entire composition. Therefore, his diagonals refused to recede. They functioned as two-dimensional design elements while simultaneously alluding to space (Plate 13).

Vivin never escaped from his dingy tenement. What little success he had during his lifetime came too late. He died in 1936, hardly more than a decade after his work had begun to attract attention. Bombois, who was also first

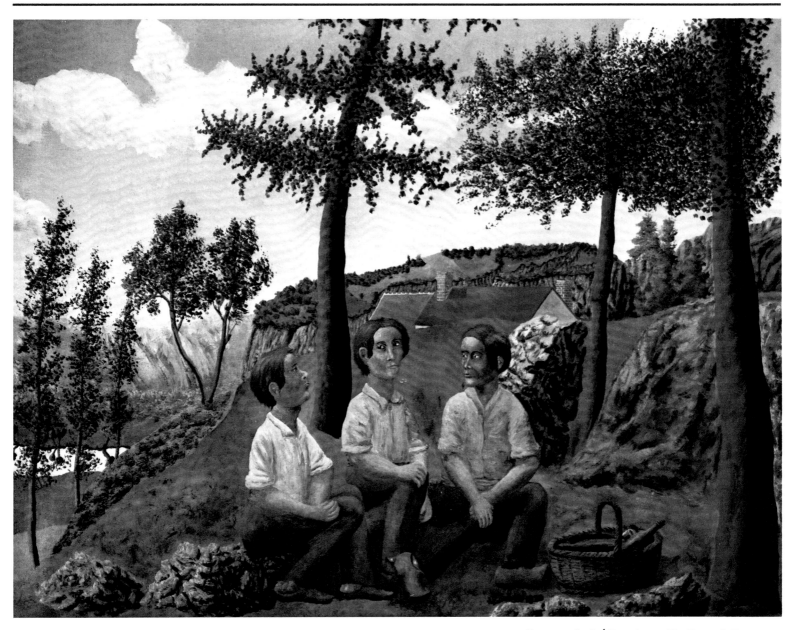

Figure 47. **André Bauchant.** The Farmer's Rest. 1929.

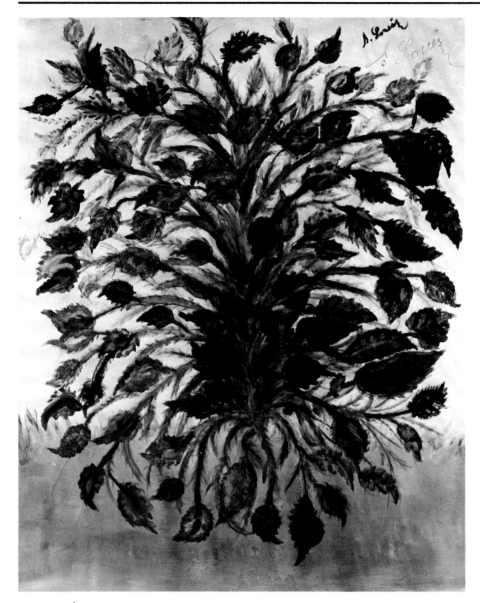

Figure 48. **Séraphine Louis.** Flowers. Ca. 1920–30.

discovered on the streets of Montmartre, fared much better. He was thirty-nine when, in 1922, he decided to display some of his "amateur" paintings in an outdoor art show. The response was such that it was not long before he was able to support himself solely by painting. In time, he earned enough to leave Paris and buy a home in the country.

Before becoming an artist, Bombois had been a farmhand, a wrestler, and a circus strongman. Later, he had helped build the Paris subway and worked in a newspaper plant. It was to his earliest experiences that he returned in his art, just as physically he returned to the French countryside where he had spent his childhood. He was a robust man, and he peopled his painted world with ample women and stocky peasant types. The buxom circus performer became so associated with his imagery that one is at first taken aback by the pastoral lyricism of *End of the Harvest in Champagne* (Plate 15). This, too, was part of the world of Bombois.

If Vivin invented a schematized realism, Bombois created a tangible one. Every variation of texture and substance is recorded in his *Old Man at the Gate* (Plate 14): the planks of the gate, the large and small stones, the stucco, the bark of a tree, the dirt, the grass, and the sky. Indeed, his is such a palpable reality that it is surprising to hear Bombois called a surrealist. Yet it is just this intimately felt realism, divorced from the academic pictorial conventions of realism, which appears surreal. Bombois has perhaps succeeded in capturing that "inner resonance of the thing" of which Kandinsky spoke.

Of all the members of the Sacred Heart group, Bauchant received the most overt attention from established cultural figures. He was forty-six when he decided to turn his full attention to painting, and forty-nine when he made his first sales to Le Corbusier, Ozenfant, and Lipchitz. Several years later he was commissioned by Diaghilev to design stage sets for the performance of a Stravinsky ballet.

Bauchant was the most sophisticated of Uhde's five. He was well read, and had traveled extensively — not sealed inside a windowless carriage, but with his eyes wide open. From museums he had visited, from texts he had read, he seems to have drawn much of his early subject matter. His paintings bore titles such as *Pericles Accounting for His Use of Public Monies* and *The Rescue of Andromeda by Perseus.* He must have judged such intellectual themes

Figure 49. **Dominique Lagru.** Self-Portrait. 1956.

Figure 50. **Dominique Lagru in His Little Studio.** 1957.

appropriate to the domain of art. Nonetheless, before he had become an artist, he had been a gardener. His landscapes and depictions of flowers, drawn from observed reality rather than the history of image-making, have an immediacy lacking in some of his mythological and historical pieces. Here, in works like *The Farmers' Rest* (Figure 47), we find a variant of that same "surrealism" ascribed to Bombois. The personal experience of reality, depicted in a nonacademic fashion, seems to penetrate to an underlying essence absent in conventional realism.

Figure 51. **Jules Lefranc.** Moulin de la Galette, Rue Girardon, Paris. Before 1957.

Séraphine Louis, the first of Uhde's discoveries, was his most personal and also his most dubious one. It seems almost too good to be true that a naïve painter of amazing talent should happen to be the housekeeper of an art dealer specializing in naïve painters. Séraphine *was* Uhde's housekeeper in the little town of Senlis outside of Paris. But her work, though striking, cannot be said to belong with that of other self-taught artists. Séraphine was a psychotic, and her paintings bear the characteristic stamp of her illness. As one writer describes it, "The person who is mentally ill can only develop the forms and figures residing in him, while the naïve painter freely chooses his motifs."[84] Séraphine's single subject — wildly colored floral arrangements — was pursued with manic intensity (Figure 48). Her addled mind wandered in and out among fronds and petals, which were intertwined and overlapped in a maze from which she could not escape.

The activities of Uhde and others on behalf of the self-taught artist gave legitimacy to the efforts of people who would previously have been ignored. Thus it became possible not only for men of exceptional talent like Henri Rousseau to gain an audience, but also for those of only average abilities to find a market for their work. Neither Dominique Lagru nor Jules Lefranc was an artist of singular genius, but both were talented. Born in another era, they might have become folk craftsmen, creating solid, useful objects of surpassing grace. Lagru was a herdsman; Lefranc ran a hardware store in Laval, Rousseau's birthplace. The one was concerned with a bucolic vision, the other with an urban one. Lagru was interested in the textures and patterns of nature (Figure 42). Lefranc championed the solid forms of man-made structures (Figure 51). Their paintings are attractive and well made, if not extraordinary.

It has been said that the presence of such secondary talents corrupts the integrity of the entire field of naïve art. If this is so, then one must consider the realm of academic painting even more corrupted by the far greater number of mediocre artists it has produced. It is in the nature of all the arts that not everyone who feels called upon to serve them will be equally qualified to do so. Thus it was natural that, as naïve painting became a recognized field of endeavor, its ranks would attract a broad range of artists of varying talent.

American Nonacademic Painting

In the United States, twentieth-century folk painting was a continuation of the tradition already established in the nineteenth century. In this "land of opportunity," there had always been a sense that art, just like everything else, was open to anyone who cared to give it a try. The amateur more or less took up where the professional left off. The art training that was being introduced to the schools, the establishment of museums, the easy availability of lithographic prints, all made art more accessible to the common citizen. Census figures show that between 1830 and 1850, while the number of limners declined, the number of art supply stores serving the general public tripled.[85]

The Swedish immigrant Olof Krans, like so many nonacademic nineteenth-century artists, started his career as a craftsman, a painter of signs and houses. Willing to undertake any sort of painting assignment, he received some commissions that merged craft with art. After one such project — a stage curtain for a local community center — won him special praise, he began to devote his full attention to painting for its own sake. He is best remembered for his canvases recounting the history of the refugee colony in which he grew up. Far more numerous, however, are his paintings copied from printed illustrations or photographs.[86]

Another who grew out of the crafts tradition was the Pennsylvania artist Joseph Pickett. Able to handle most any mechanical task, for many years he applied his skills to decorating the concessions he ran at traveling carnivals. Only in his forties did he finally marry and settle down to run a small grocery store. It was in these later years that Pickett acquired the time and inclination to paint. Very few works by him are known to exist, perhaps because for a time they were considered too insignificant to keep. Possibly his known habit of devoting years to building up paint textures on a single piece limited his production. *Lehigh Canal, Sunset, New Hope, Pa.* (Plate 16), his latest surviving painting, indicates Pickett's sure command of color and composition. As in the work of other nonacademic painters, spatial planes are reduced to two-dimensional entities, thus placing greater emphasis on overall design than on realistic verisimilitude. Further simplification is achieved by restricting the palette to shades of red/brown, yellow, and green. It is by developing and perfecting such self-imposed limitations that the nonacademic artist creates style.

Figure 52. **Olof Krans.** Olson Farm, Sweden, 1900. 1900.

Figure 53. **John Kane.** Junction Hollow. 1932.

The amateur painter was tolerated in America at this time, but not terribly well appreciated. As Pickett's wife put it, "If Joe wants to paint and does not get paint on the carpet, it's all right with me."[87] The amateur who wanted to paint had to be content to earn his or her living some other way. As in France, the first "popular primitives" in America were not initially artists by profession.

Thus John Kane had to struggle to find an outlet for his interest in art. In his day, he had done almost everything. He had worked at coal mining and farming, had been a carpenter and a house painter. He was painting boxcars when he first awoke to the creative possibilities of paint. For a time afterward, he earned a modest living coloring in photographic enlargements and peddling them door-to-

door. Gradually he began to paint more in his spare time, bringing home scraps of board from his construction jobs to use in lieu of canvas. Perhaps prompted by his success with the painted photographs, he tried to sell people painted "portraits" of their houses. Layoffs and slack periods plagued the industries from which he drew his steady income, and increasingly he turned to painting to fill the gaps.

Toward the end of Kane's life, several events coincided to focus his attention more completely on art. Old age and the Depression limited the number of industrial jobs open to him. And in 1927, on his third try, one of his paintings was accepted by the jury of the Carnegie International exhibition. Thereafter, he participated in this prestigious

Figure 54. **John Kane.** The Monongahela River Valley. 1931.

annual event every year until his death. His paintings were shown in major museums across the country, and in 1930 the Phillips Memorial Gallery became the first museum to acquire one.

In this painting, *Across the Strip* (Plate 17), we see the milieu in which Kane spent his final days: one of the worst slums in Pittsburgh. Here are all the typical signs of urban decay — the smashed windows and abandoned buildings. But here too, from Kane's point of view, were vital people struggling to live decently, with curtains in the windows of their tenements and clean laundry hanging outside to dry. The patterns and contrasts of the city are used to give structure and texture to the painting. The uniform drab grays and browns achieve a pictorial unity reminiscent of

the cubists' reductive use of color. However, the personal details and contrasting soft forms of the clouds and distant hills make this a masterpiece not of abstraction, but of social documentation. Kane also painted scenes recalling his Scottish childhood, portraits and bucolic idylls, but it is as a recorder of urban America that he is best remembered.

Fame was not denied Kane, but what fortune there lay in it lagged too far behind to ever be of any use to him. For Horace Pippin, a self-taught black painter discovered three years after Kane's death, fame had even more unfortunate consequences. There was adequate remuneration for Pippin, who lived to see Hollywood collec-

tors competing to acquire his paintings at sell-out exhibitions. After a life of poverty devoted to the menial jobs reserved for those of his race, success bewildered Pippin. He spent his money as quickly as he made it on liquor and women. At heart, he was miserably unhappy, and his wife was literally driven insane by the sudden change in their circumstances.

As an artist, Pippin explored the themes he found most meaningful: the First World War (for he had been profoundly affected by his experiences as a soldier), historical subjects with a personal resonance, Biblical scenes (for he was deeply religious), and depictions of the everyday life he knew best. He liked to work up a thick impasto, and treated every color area individually. "I work my foreground from the background," he wrote. "That throws the background area away from the foreground. In other words, bringing out my work."[88] This resulted in compositions composed of color units subordinated to the requirements of personal narrative. In his *Interior* of 1944 (Plate 21), each element is distinctly arrayed in the simple formal sequence that most directly conveys the artist's experience. Pippin is one of the most "artless" painters of his generation, for his work has an immediacy that transcends aesthetic considerations.

Another who worked creatively with the substance and texture of paint was Morris Hirshfield. When, after a long career in the New York garment industry, he turned to painting, his work betrayed traces of his earlier activities. His preliminary sketches were modeled on the large patterns used by tailors. His textures, which he carefully groomed with combs, were those of furs and fabrics. Compositionally, his work is more limited than the extensive personal landscapes favored by the other self-taught artists of his era. His formal devices are almost strictly two-dimensional, with only vague spatial references (Plate 23).

Hirshfield, Pippin, Kane — all died within a few years of receiving public recognition. None of them lived to see painting become a steady source of income over an extended period of time. One can only speculate as to what continued success might have meant to them, personally and artistically. The transition from amateur to professional status poses both challenges and risks. The challenge is for the painter to grow and develop just as outstanding academic artists have. The risk is to fail. Kane, Pippin, and Hirshfield never had the opportunity to meet that challenge. One painter introduced to the American public

around the same time did: Anna Mary Robertson (Grandma) Moses.

No one could have predicted that Moses, eighty years old at the time of her first one-woman show in New York, would live to paint for another twenty-one years. During that time, she attained the status of a legend. She became a beacon of hope to the elderly, and, for an America now deeply ensconced in the twentieth century, a symbol of a simpler era. She was feted by the President, honored by the Governor, and interviewed on television by Edward R. Murrow. Her paintings were sent around the world in traveling exhibitions and as reproductions on Hallmark greeting cards. Her picturesque story made the covers of both *Time* and *Life* magazines. For some critics, fame obscured the genuine merits of her work. But in the final analysis it must be said that Moses, put to the challenge, performed valiantly.

Moses's background was not very different from that of the other nonacademics of her day. Like them, she had spent most of her life pursuing an occupation considered more practical than art; in her case, that of a farmer and housewife. Spurred by a pleasure in drawing and a delight in "pretty things" that went back to early childhood, she turned to painting to while away the idle hours of her old age.

"American art is beautiful, cheerful, and greeting cards are very nice," she wrote when asked to express her tastes in art.[89] Like many self-taught painters — Hicks, Rousseau, Vivin, Pippin, Hirshfield — she cherished printed illustrations, which served as models and instructional aids. Like them, she took such imagery as a point of departure and transformed it to her own ends. Her colorful rendition of *The Burning of Troy in 1862* (Figure 57), derived from a black-and-white newspaper clipping (Figure 58), offers a greatly expanded version of the event, incorporating a full landscape background as well as an enlarged foreground.

The "Grandma Moses style" was an amalgam of two separate influences: details derived from prints and an intuitive feeling for landscape derived from direct observation. In a monumental canvas like *Hoosick Valley* (Plate 18), one sees clearly how these details were reduced to geometrical abstracts and subordinated to the sweep of the whole. Like Vivin, Moses devised her own method of conveying distance. The diminishing size of the objects, the subtle gradation of hues from yellow-green in the foreground to slate blue, and the graceful intersecting curves of roads and river all result in a composition that is both three-dimensionally convincing and aesthetically innovative.

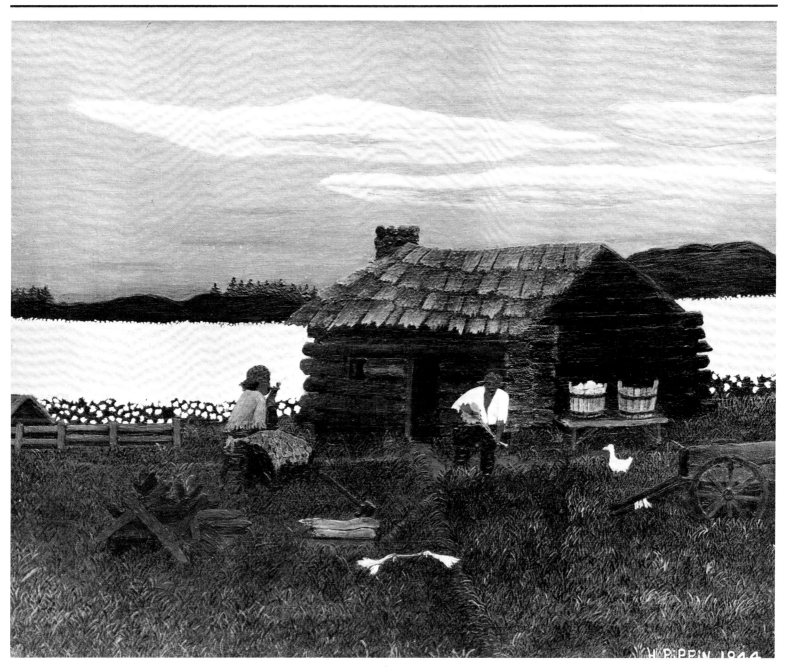

Figure 55. **Horace Pippin.** Cabin in the Cotton III. 1944.

Figure 56. **Anna Mary Robertson Moses.** 1949.

Moses was unusual in not only sustaining her ability to produce masterful formal arrangements, but actually expanding upon and developing it. With time and experience she learned to further modify the anecdotal elements, allowing color and brushwork to dominate. Thus in a late painting, *White Birches* (Plate 19), background details such as the houses become looser, merging in color and texture with the almost expressionistic foliage. Moses achieved a painterly unity in her work which places it on the same level as that of the great academically trained landscape painters.

The Moses phenomenon was an example of the success possible for the self-taught artist. In truth, no other ever equaled her in this respect. But it cannot be denied that this sort of success had a profound effect on the status of nonacademic art. How easy it seemed to paint in the "primitive" style! In Moses's family alone, there were a number of members willing to try their hands at it. Of them all, only one — her brother Fred Robertson — displayed a genuine originality (Figure 61). Needless to say, he did not paint in the "Moses style." He had a Robertson style all his own.

Of course, not everyone could be an overnight success. There were plenty of artists like Clara McDonald Williamson who enjoyed quiet reputations. In many ways, Williamson's story parallels that of Moses. She lived an essentially rural life on the Texas frontier. After the death of her husband, a shopkeeper, she sought to develop a long-suppressed interest in art by enrolling in evening classes at a local university. In the following years, her work was exhibited widely, and even acquired by the Museum of Modern Art. Still, her fame remained most pronounced in her native Texas, despite the undeniable quality of her art. Perhaps her discovery in 1945 had come just a few years too late, or maybe she made a crucial mistake early on in refusing representation by a prestigious New York gallery. Possibly America had room in its heart for only one "Grandma Moses," and so "Aunt Clara" was forced to play a secondary role.

One thing was certain: the novelty appeal of the painting amateur had to wear off eventually. And then, too, once the doors of the art world were flung open to the untrained, there was a danger that standards would be trampled in the stampede. Sidney Janis, writing one of the first surveys of twentieth-century American naïve art in 1942, focused on thirty painters and was, at the time, gently criticized by Museum of Modern Art Director Alfred Barr for being a little too all-inclusive.[90] Three decades later, an

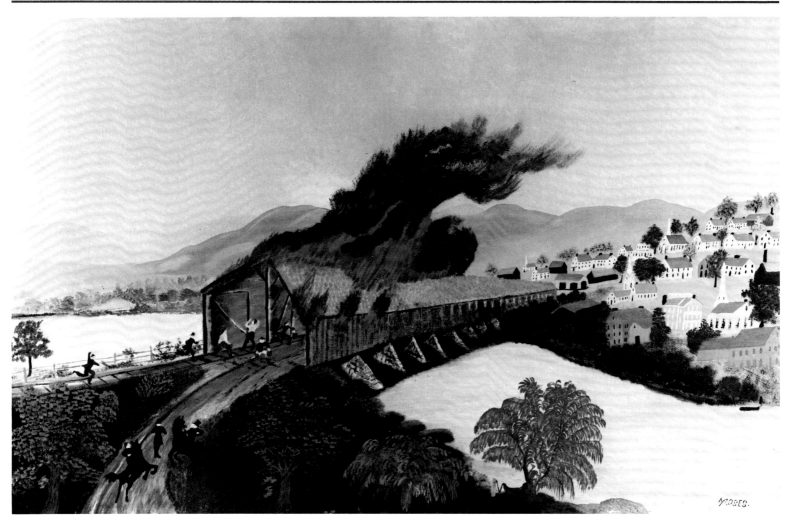

Figure 57. **Anna Mary Robertson Moses.** The Burning of Troy in 1862. 1943.

Figure 58. **The Bridge that Started the Great Fire of 1862.**

Figure 59. **The Hands of Grandma Moses.**

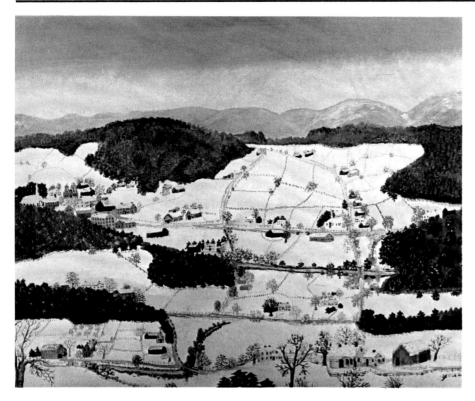

Figure 60. **Anna Mary Robertson Moses.** Cambridge Valley in Winter. 1944.

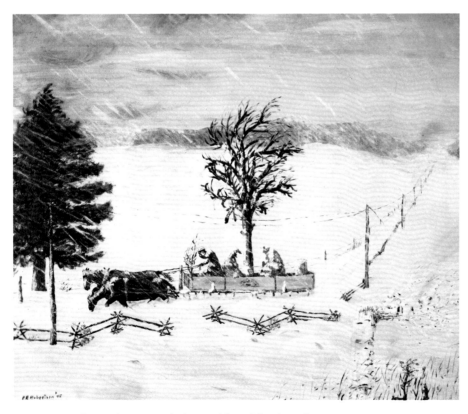

Figure 61. **Fred E. Robertson.** Black River Thaw (The Blizzard). 1945.

updated study of the same subject counted no fewer than 145 artists worthy of discussion.[91] Interestingly, only fifteen of Janis's original thirty made it into the new book. Nonetheless, Janis must be considered a relatively reliable prophet, for it seems highly unlikely that half of the 145 artists in the more recent publication will be remembered thirty years hence.

As more attention was accorded the self-taught artist, it became apparent that he or she often suffered from certain limitations. Although it is obvious to point to lack of training as the culprit, this is at best an oversimplification. Dedicated artists can teach themselves to handle paint effectively, and will invent sophisticated techniques which, though different from those they might have learned in school, are more directly suited to their intentions. The crucial issue is not method but manner. The self-taught artist must invent a style, must pioneer an idiom tailor-made to his or her unique needs. Only the greatest academic artists are capable of transcending their training to achieve a unique style. It is, therefore, not surprising that the nonacademic artist is sometimes only partially successful.

For some, continued development after the initial breakthrough is difficult. Clara Williamson's first major painting, *Chicken for Dinner* (Figure 62), is also her greatest. Other artists produce an oeuvre that is surprisingly uneven. Sometimes working from printed sources, they may create many pieces that are lifeless adaptations, and only a few in which a truly original style is achieved. That such artists have an incentive to keep trying is one of the important consequences of the popularization of naïve painting.

To this we owe the isolated achievements of Nan Phelps, who has pursued a lifelong dedication to art encouraged only by moderate community support and sporadic assistance from a New York gallery. Phelps is not a famous artist; in fact, she is almost completely unknown. In 1947 she created one of her first major works, a life-sized portrait of her mother (Plate 24), which shows a feeling for form and pattern similar to that of nineteenth-century limner images. Some thirty years later, working in a totally different vein, she turned a complex crowd scene into an intricate arabesque of abstract form and detail. *Riverfront Stadium: Phillies and Reds* (Plate 25) is a work entirely contemporary in its subject matter and its execution. A strong and original painting, it may be taken as visual proof that modern society has not (as some contend) rendered nonacademic art obsolete.

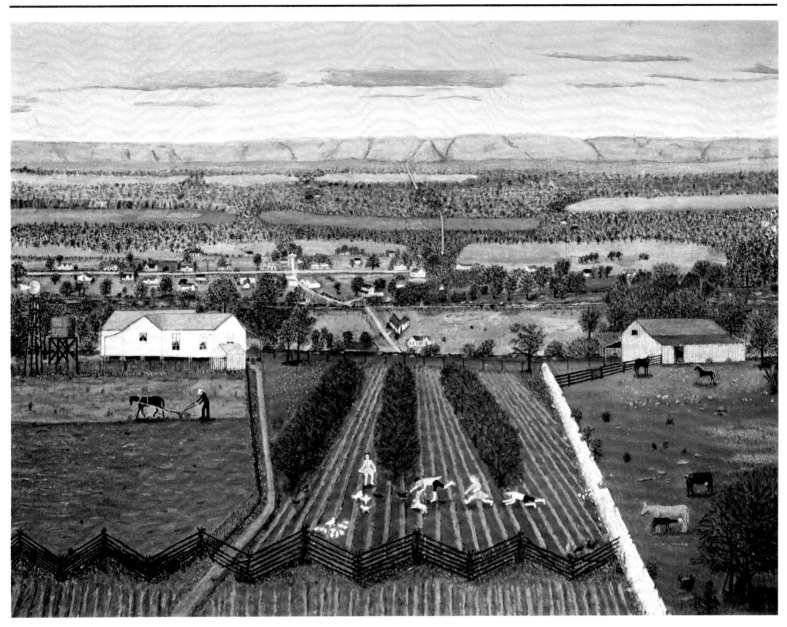

Figure 62. **Clara McDonald Williamson.** Chicken for Dinner. 1945.

Yugoslavia: A Modern Peasant Revival

Figure 63. **Professor Krsto Hegedušić.** 1962.

Nonacademic art in the twentieth century was hindered not so much by technological advances as by growing self-consciousness. That spontaneity so crucial to the creativity of the self-taught was jeopardized when these artists were exposed to public scrutiny. The results of such studied naïveté, which is today prevalent throughout the world, may be seen in microcosm in the Yugoslav phenomenon.

The so-called Yugoslav primitive school was the deliberate creation of a relatively sophisticated artist, Krsto Hegedušić. Yugoslavia, though geographically isolated, was, like the rest of Europe, influenced by an influx of avant-garde aesthetic ideas after the First World War. These concepts seemed particularly alienating to socially motivated Yugoslav artists who were trying to give vent to nationalistic impulses in their art. In 1929, to counter the modern forces, they founded a group they called "Earth." As the name implies, the group sought a return to certain national basics. Inspired by this ideology, Hegedušić, a cofounder of Earth, decided to teach art in the rural Croatian community of Hlebine.

In 1930 he began giving lessons to a young peasant named Ivan Generalić, and the following year he acquired a second pupil, Franjo Mraz. Hegedušić, Generalić, and Mraz established an artistic identity by exhibiting together in the provincial capital of Zagreb and attracted another artist, Mirko Virius, to their midst. The full-scale spread of the primitive "school" did not, however, really begin until after World War II. By this time the original group had begun to disintegrate. Virius was killed in a concentration camp, and Mraz had temporarily given up painting. Fortunately, there were many new talents in Hlebine ready to replace them. Neighboring villages, too, came under the influence of what came to be looked upon as the "Hlebine style." Similar groups sprang up in Serbia and Slovenia as well. Individuals such as Emerick Feješ and Ivan Rabuzin, unaffiliated with any larger group, continued the tradition in their own ways.

Hegedušić's initial teaching had laid heavy emphasis on the tradition of reverse-glass painting. Not only was this a medium with a long and authentic history, but it was relatively simple to master. Preliminary sketches, placed underneath a transparent pane of glass, could be easily traced. Elementary blocks of color became more intense and almost iridescent when reflected through glass. The technique was, in fact, extraordinarily beautiful. Colors revealed a luminosity impossible on an opaque support. As Generalić put it, "Canvas somehow swallowed up my colors, made them look dull, and besides, I couldn't show

Figure 64. **Ivan Generalić's Worktable and Tools.**

Figure 65. **Ivan Generalić.** 1962.

all the details I wanted, not in such a clear way."[92] A line painted on glass does not bleed. It retains a true, crisp edge. Glass painting reverses the usual sequence of building a composition. Objects in the foreground must be painted first, and, once painted, cannot be altered. The background is then filled in from behind. This procedure had a definite effect on the design possibilities open to the Yugoslavs, for it encouraged the isolation of decorative forms in the foreground and the creation of softer, more lyrical backgrounds (Plate 26).

Hegedušić had suggested that the peasants draw their subject matter from their own experiences. In the decades after World War II, however, the incursion of modern conveniences began to transform the traditional rural life-style: farm chores became more mechanized; schooling became more important than churchgoing; television re-

Figure 66. **Dragan Gaži.** 1962.

Figure 67. **Dragan Gaži.** The Black Horse. 1962.

placed community-oriented live entertainment. The result was that just when the primitive school was beginning to attract new members and meaningful outside support, it lost its contextual rationale.

Gradually, the Yugoslav style became synthetic. Fantasy replaced direct experience in the work of peasants who lacked an authentic "primitive" background. The technical and regional limitations of their approach resulted in stylization. The Yugoslav artist perpetuated a group style instead of the personal style that is the hallmark of the nonacademic painter.

The Yugoslav school had always involved a certain contradiction in terms. Its overt ties to sophisticated art circles and its obviously nonutilitarian function clearly separated it from the folk crafts tradition to which it claimed an allegiance. On the other hand, their reliance on group standards distinguished the Yugoslav artists from the other nonacademics, who pursued a more individualistic course. There can be no schools in the world of nonacademic painting, for the very notion of a school implies submission to an overriding aesthetic. The genuine nonacademic painter remains free of such subjugation.

However, this does not mean that all the paintings produced by the Yugoslavs were "bad," or lacking in individual variations. After all, not every painting done by students of European art academies is "bad." It is possible to excel within the confines of a traditional training and even to transcend it. Dragan Gaži, for example, preserved a deep personal identification with his peasant heritage, as evidenced by his poignant portrait of a rural umbrella maker (Plate 29). The crisp outline of his *Black Horse* (Figure 67), frozen against the turbulent winter landscape, achieves a striking effect. The simplified palette of grays and browns serves to increase the contrast between these elements. Stjepan Stolnik's exaggerated colors (Plate 28) bespeak a desire to overemphasize the dramatic possibilities of the medium. Nevertheless, the block forms in the foreground make an effective foil for the delicate hues in the background landscape.

Of all the latter-day masters of Yugoslavia, the least appealing are those who have deliberately limited themselves to the lifeless replication of a set style. Rabuzin's flower pieces and landscapes (Figures 69, 70 and 71) were initially a truly original stylistic innovation. His simplified rounded forms and overlapping pointillistic dots in delicate pastel shades set him apart from all the other Yugoslavs. Through the endless repetition of similar motifs, however, his work, now marketed worldwide through lithographic reproductions, has become purely decorative.

Conclusion

For centuries the nonacademic artist worked in the shadows of civilization. He or she had recourse to an age-old craft tradition on the one hand, and academic art on the other. Nonacademic painting filled the gap between the two. Its practitioners were largely self-taught, but not uninfluenced. The nonacademic artist, like all visually sensitive people, was highly conscious of aesthetic objects in his or her immediate environment. Careful observation of these objects, and the appropriation of those aspects best suited to the artist's personal expressive needs, contributed to the development of an individual style. Like all styles, it was based in part on what had come before. The difference between nonacademic and academic style lay in the nonacademic artist's freedom in incorporating outside influences and adapting them to his or her particular purposes.

In the twentieth century, there were radical changes in the art forms—folk and academic—which constituted the points of reference for nonacademic painting. Folk crafts lost their economic support, and the art academies were reformed by the avant-garde. In the process, nonacademic art emerged from the shadows. This did not produce a change so much in its intrinsic nature as in the nature of its circumstances. Folk art was accorded a prestige never known before.

Fame was an unexpected development for the first self-taught artists who received it. Those who had experienced full lives dedicated to hard work could not take it too seriously. "I was proud and glad to have this recognition at last," John Kane wrote of his acceptance by the Carnegie International, "but beyond that, it was of little importance. I have had too many hardships in a long life. I have lived too long the life of the poor to attach undue importance to the honors of the art world or to any honors that come from man and not from God."[93] "As for the publicity and as for the fame," said Grandma Moses simply, "...that I am too old to care for now."[94]

It was possible to resist the bedazzlement of fame, but far more insidious were the outside influences that came with it. Descended upon by the lofty forces of the art world, the self-taught artist had to contend with advice received from sophisticated people of seemingly superior knowledge. "Occasionally I could not resist ... suggesting changes in details that seemed less effective than they might be," Uhde mused. "Vivin never took my advice.... In this respect he was quite different from Rousseau [who] would often ask me whether, for the sake of balance and harmony, this or that detail should be darker or lighter. Now and then Séraphine would ask similar questions."[95]

Generalić earnestly claimed to have been uninfluenced: "If I had paid much attention to the advice that in its time was given me, I would have done very different things."[96] Yet influences can be elusive. Hegedušić, in selecting a model for his peasant art movement, was swayed by the work of Breughel. And Generalić, though he said he had never heard of Breughel, was exposed to his style through its effect on Hegedušić.

It was natural that the art world personalities who cultivated self-taught artists should associate them with the acknowledged masters of the genre. Thus Pippin was taken to see the Rousseaus at the Barnes Foundation and, possibly inspired by a Hicks belonging to his art dealer, painted his own renditions of the "peaceable kingdom" (Plate 22). When jungle monkeys appear in Bauchant's work, we do not hesitate to guess where the idea came from. Scenes of the tropics will forever be the territory of Henri Rousseau, upon which other self-taught artists trespass at their own risk. As Hirshfield, too, came in contact with Rousseau's work, we must ask whether it was not the Douanier's example that prompted this Lithuanian emigré garment worker to paint canvases of jungle animals. We know that Hirshfield was struggling to come to terms with the nude in Rousseau's *The Dream* when his biographer's wife suggested he try a similar subject.[97]

It is a curious fact that our knowledge of the twentieth-century naïve is often largely dependent on the work done by a single biographer. Uhde, of course, is the most obvious example of this, but is by no means the only one. Kane was revealed to us by Marie McSwigen, the newspaperwoman who helped him write his autobiography. Sidney Janis came to be associated with Hirshfield; Otto Kallir was the biographer of Moses; Selden Rodman wrote the first important book on Pippin; Donald Vogel championed Williamson. Maybe it was in the nature of the nonacademic artist to require a translator to present his or her work to the academic community. In many cases, the biographers were also mentors who stood by their artists offering advice and moral support. In all cases, these writers performed an invaluable service by preserving firsthand the artists' recollections and opinions. This was at least one way in which nonacademic art benefited by its emergence from the shadows. For the first time there was a record of how the nonacademic painter viewed his or her vocation.

The self-taught artist was approached like a sideshow curiosity and asked by an inquisitive public to deliver essays on the topic "How Do I Paint?" Some responded quite literally. "Before I start painting, I get a frame, then I

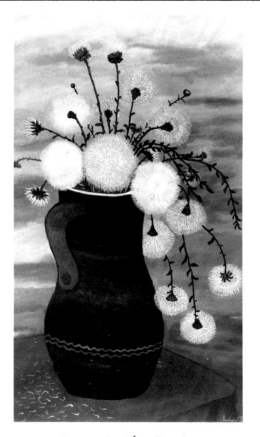

Figure 68. **Ivan Lacković.** Yellow Flowers. 1965.

Figure 69. **Ivan Rabuzin.** Red Vase. 1964.

saw my Masonite board to fit the frame," Moses explained. "Then I go over the board with linseed oil, then with three coats of flat white paint."[98] Others were surprisingly articulate about their work, and, even more surprising, they articulated similar sentiments. "My opinion of art is that man should have love for it, because my idea is that he paints from his heart and his mind," wrote Pippin. "To me it seems impossible for another to teach one of art."[99] "Schools and advice aren't much help," agreed Generalić. "You follow seriously what you feel inside, with diligence and passion, and you arrive."[100] One of the most eloquent statements was delivered by Kane: "Of greater importance than technical accomplishment, I have always held, is that unity of handiwork with deep convictions, profound thought and lofty taste that, working together, create a great work of art."[101]

Two roads — realism and abstraction — Kandinsky said, would lead the artist to capturing the inner resonance of the thing, once the stranglehold of the academies had been broken. It was, theoretically, possible. It was possible that with the abolition of academic training by modernism all painters might become essentially self-taught. With self-expression as a common goal, artists might freely choose either a realistic or an abstract approach, and the result would be essentially the same. This is not what happened.

Those artists who were truly self-taught tended to elect the realistic path, because realism is more directly accessible to those who have not been exposed to complex aesthetic ideas. Most of them had never heard of Kandinsky, and surely none of them was conversant with the intricacies of his theories. Still, their statements on art indicate the extent to which they personified his precepts. Even if their statements did not confirm this, their art would, for each self-taught artist created a distinct personal style geared to capturing the "inner resonance of the thing" as he or she perceived it.

Of Kandinsky's two alternatives, abstraction was the more intellectually complex, and maybe that is why his two roads did not converge, but rather ran a parallel course. Serious art criticism and scholarship concentrated on abstraction. As time passed, the history of modern art came to be written as the ineluctable reduction of form. Abstraction was taught in the art schools and became as entrenched as ever any academic style had been. Naïve painting was seen as an amusing sideline. Only Rousseau, because of his close association with the pioneers of

Figure 70. **Ivan Rabuzin.** Flowers. 1964.

Figure 71. **Ivan Rabuzin.** The Forest. 1964.

modernism in its heroic period, was admitted to the standard texts on nineteenth- and twentieth-century art.

There were other reasons why naïve painting came to be discredited. It had always seemed deceptively easy to paint in the "primitive" style. Many was the time a cynical observer commented, "My three-year-old child could do better than that." Still, similar witticisms were prompted by the masterpieces of abstraction, and naïve painting was actually, because of its realism, more palatable to the general public. The very popularity of naïve art tainted it in the eyes of some elitist critics. Most damaging to its reputation was the fact that, while abstraction was becoming entrenched in the academies, primitivism was becoming entrenched in the marketplace.

Nonacademic painting is not a style. It is a nonstyle or, if you will, a personal style. However, every person who creates a style — every Henri Rousseau, every Grandma Moses, every Ivan Generalić — invites others to follow in his or her footsteps. Any style, once established, can be imitated. Furthermore, self-taught artists can draw upon the work of other self-taught artists, just as they once drew more or less exclusively upon academic and popular sources, creating a potentially debilitating sort of inbreeding. Finally, there is a temptation for self-taught artists who

have created personal idioms to become imitators of themselves, cloning their own styles mechanically and without feeling.

Discussions of the future of nonacademic painting often center on the inability of artists living in modern society to avoid influence by the mass media. Such worries are overly affected by terms like "naïve" and "primitive" that presume an exceptional degree of innocence or ignorance on the part of the artist. Nonacademic painting has never been predicated on ignorance of outside culture; on the contrary, it has fed off that culture.

There will always be nonacademic art so long as there are artists willing and able to create their own styles in accordance with their own instincts. But when nonacademic painting becomes a style of its own, it is no longer nonacademic, because the tyranny of style reduces the artist's freedom of choice. Similarly, abstraction was never meant to be confined to the rigid stylistic boundaries imposed by academicization. At the very heart of the dilemma of nonacademic art lies the present dilemma of art itself.

Notes

1. Holger Cahill organized the first significant exhibition of American folk art in 1930 at the Newark Museum. Subsequently, he contributed essays to the catalogues of two groundbreaking shows at the Museum of Modern Art: *The Art of the Common Man* (1932) and *Masters of Popular Painting* (1938).

2. "What is American Folk Art?," reprinted from *The Magazine Antiques* (May 1950) in *Folk Art in America,* Jack T. Ericson, ed. (New York: Mayflower Books, 1979), p. 15.

3. Jean Lipman, *American Primitive Painting* (New York: Oxford University Press, 1942), p. 3.

4. Many of the writers who contributed essays to *Primitive Painters in America* (Jean Lipman and Alice Winchester, eds., 1950) took special pains to be critically objective about the artists, as does Otto Bihalji-Merin in his *Modern Primitives* (1971). Ida Niggli attempted to launch an all-out attack on the prevalence of false primitives in *Naïve Art* (1976), but was somewhat too impassioned to be objective.

5. Andrew Martindale, *The Rise of the Artist in the Middle Ages and Early Renaissance* (New York: McGraw-Hill Book Co., 1972).

6. Jean Cuisenier, *French Folk Art* (New York: Kodansha International, 1976), p. 92.

7. Ibid., p. 161.

8. Robert Wildhaber, *Swiss Folk Art* (German Arts Council and Pro Helvetia Foundation, 1968), p. 9.

9. It is often said that Europe lacks a substantial tradition of folk painting, yet one must be wary of such blanket generalizations. What can be said with certainty is that European folk painting has not been researched nearly as extensively as its American counterpart. The mere fact that some samples of European folk painting are known to exist suggests that there must be many more waiting to be unearthed. Furthermore, since folk painting in America dates back to the earliest Colonial days, it is to be assumed that European immigrants brought the practice with them, rather than developing it spontaneously on foreign soil.

10. Ernst Schlee, *German Folk Art* (New York: Kodansha International, 1980), p. 11.

11. Tamás Hofer and Edit Fél, *Hungarian Folk Art* (New York: Oxford University Press, 1979), p. 56.

12. Ibid., p. 34.

13. Schlee, op. cit., p. 213.

14. Cuisenier, op. cit., pp. 97 – 98.

15. Friedrich Knaipp, "Volkstümliche Hinterglasbilder des 18. und 19. Jahrhunderts," *Österreichischer Volkskundeatlas.*

16. James Ayres, *British Folk Art* (Woodstock, N.Y.: The Overlook Press, 1977), p. 100.

17. Schlee, op. cit., p. 213.

18. Knaipp, op. cit.

19. Cuisenier, op. cit., p. 92.

20. The word *santo* is used in Spanish as both adjective and noun, meaning "holy" or "holy person or object."

21. E. Boyd, *The New Mexico Santero* (Santa Fe: Museum of New Mexico Press, 1969), pp. 5 – 6.

22. Christine Mather, *Baroque to Folk* (Santa Fe: Museum of New Mexico Press, 1980), p. 19.

23. Ibid., p. 11.

24. E. Boyd, *Popular Arts of Spanish New Mexico* (Santa Fe: Museum of New Mexico Press, 1974), pp. 79 – 80.

25. Robert Bishop, *Folk Painters of America* (New York: E. P. Dutton & Co., 1979), p. 226.

26. Ida Niggli, *Naïve Art* (Niederteufen: Verlag Arthur Niggli AG, 1976), p. 24.

27. At the time of the first census, German immigrants comprised 8.6 percent of the population of the United States, making them the second largest national group. In the late seventeenth century, William Penn had dispatched agents to the Rhineland to recruit settlers for rural Pennsylvania. Herein lay the origin of the so-called "Pennsylvania Dutch" (a corruption of *deutsch*) folk art, the most distinctive European peasant tradition transplanted to the United States.

28. Ayres, op. cit., p. 102.

29. Bishop, op. cit., p. 12.

30. Ayres, op. cit., p. 95.

31. Susan Burrows Swan, *Plain and Fancy* (New York: Holt, Rinehart and Winston, 1977), pp. 51 – 52.

32. Ayres, op. cit., p. 93.

33. Jean Lipman and Alice Winchester, *The Flowering of American Folk Art (1776 – 1876)* (New York: The Viking Press, 1974), p. 94 (hereafter cited as *Flowering*).

34. Ayres, op. cit., p. 11.

35. Bishop, op. cit., pp. 71 – 72.

36. Ayres, op. cit., p. 93.

37. Mary Black and Barbara C. and Lawrence B. Holdridge, *Ammi Phillips: Portrait Painter 1788 – 1865* (New York: Clarkson N. Potter, 1969), p. 14.

38. Alice Ford, *Pictorial Folk Art — New England to California* (New York: The Studio Publications, 1949), p. 8.

39. Black and Holdridge, op. cit., pp. 13 – 14.

40. Jean Lipman and Alice Winchester, eds., *Primitive Painters in America 1750 – 1950* (New York: Dodd, Mead & Company, 1950), p. 73 (hereafter cited as *Primitive Painters*).

41. Lipman and Winchester, *Flowering,* p. 77.

42. Lipman and Winchester, *Primitive Painters,* p. 75.

43. Bishop, op. cit., p. 52.

44. Lipman and Winchester, *Primitive Painters,* pp. 116 – 17.

45. Ayres, op. cit., p. 91.

46. It is known, for example, that Ammi Phillips once painted a tavern sign.

47. Nina Fletcher Little, "William M. Prior, Traveling Artist,"

reprinted from *The Magazine Antiques* (January 1948) in *Portrait Painting in America,* Ellen Miles, ed. (New York: Universe Books, 1977), pp. 120–121.

48. As Nina Fletcher Little has pointed out, contemporary records fail to confirm the use of stock bodies, and it is also significant that few headless "blanks" have ever turned up. However, the repetition of poses and even the exact duplication of costumes was a common practice employed also by academically trained painters visiting from England.

49. Bishop, op. cit., p. 48. Bishop calls attention to two virtually identical portraits of sea captains, attributed to Prior's partner Hamblen, each bearing the same compositional correction. Since it is unlikely that the artist would have repeated a mistake, this suggests that the two backgrounds were painted earlier, and that the error only became obvious once the faces were filled in.

50. Eleanore Price Mather, "In Detail: Edward Hicks's Peaceable Kingdom," *Portfolio* II:2 (April/May 1980), p. 34.

51. Ibid., pp. 34–36.

52. Peter C. Marzio, *The Democratic Art, Pictures for a 19th Century America* (Boston: David R. Godine, 1979), p. 1.

53. Ibid., p. 61.

54. Martha Young Hutson, *George Henry Durrie (1820–1863)* (Santa Barbara, Calif.: Santa Barbara Museum of Art and American Art Review Press, 1977), pp. 23–30.

55. Ibid., pp. 42–43.

56. Ibid., p. 109.

57. Ibid., p. 164.

58. John Ruskin, "The Nature of Gothic" (1853), reprinted in *Arts and Crafts in Britain and America,* Isabelle Anscombe and Charlotte Gere (New York: Rizzoli International Publications, 1978), p. 11.

59. Schlee, op. cit., p. 7.

60. Paul Gauguin, letter to J. F. Willumsen (1890), reprinted in *Theories of Modern Art,* Herschel B. Chipp, ed., (Berkeley and Los Angeles: University of California Press, 1968), p. 79.

61. Paul Gauguin, "Diverses Choses" (1896–97), reprinted in Chipp, op. cit., p. 83.

62. Wassily Kandinsky, "On the Problem of Form," reprinted from *Der Blaue Reiter* (1912) in Chipp, op. cit., p. 167.

63. Holger Cahill, *American Folk Art: The Art of the Common Man 1750–1900* (New York: The Museum of Modern Art, 1932), pp. 26–27.

64. Pablo Picasso, *Picasso: Fifty Years of His Art* (New York: Museum of Modern Art, 1946), p. 270.

65. Kandinsky in Chipp, op. cit., p. 161.

66. Roger Shattuck, *The Banquet Years.* (New York: Vintage Books, 1968), p. 53.

67. Niggli, op. cit., p. 20.

68. Daniel Catton Rich, *Henri Rousseau* (New York: The Museum of Modern Art, 1942), p. 22.

69. Shattuck, op. cit., p. 61.

70. Jean Bouret, *Henri Rousseau* (Greenwich, Conn.: New York Graphic Society, 1961), p. 15.

71. Rich, op. cit., p. 30.

72. Ibid., p. 36.

73. Ibid., p. 73.

74. The Weber collection was also borrowed for the historic New York Armory Show in 1913.

75. Guillaume Apollinaire, "Henri Rousseau," reprinted from *L'Intransigent* (April 1911) in Chipp, op. cit., p. 240.

76. Wilhelm Uhde, *Five Primitive Masters* (New York: The Quadrangle Press, 1949), pp. 30–31.

77. Shattuck, op. cit., p. 45.

78. Uhde, op. cit., p. 56.

79. Rich, op. cit., p. 8.

80. Uhde, op. cit., p. 14.

81. Niggli, op. cit., p. 13.

82. Uhde, op. cit., p. 7.

83. Ibid., p. 53.

84. Otto Bihalji-Merin, *Modern Primitives* (London: Thames and Hudson, 1971), p. 29.

85. Carl W. Dreppard, "What is Primitive and What is Not?," reprinted from *The Magazine Antiques* (May 1942) in Ericson, op. cit., p. 12.

86. Jean Lipman and Tom Armstrong, eds., *American Folk Painters of Three Centuries* (New York: Hudson Hills Press, 1980), pp. 203–204.

87. Ibid., p. 208.

88. Sidney Janis, *They Taught Themselves* (New York: The Dial Press, 1942), p. 189.

89. Grandma Moses, *My Life's History,* Otto Kallir, ed. (New York: Harper & Row, Publishers, 1952), p. 141.

90. Janis, op. cit.

91. Herbert W. Hemphill, Jr., and Julia Weissman, *Twentieth Century American Folk Art and Artists* (New York: E.P. Dutton & Co., 1974).

92. Nebojša Tomašević, *The Magic World of Ivan Generalić* (New York: Rizzoli International Publications, 1975), pp. 93–94.

93. Leon Anthony Arkus, ed., *John Kane, Painter* (Pittsburgh: University of Pittsburgh Press, 1971), p. 83.

94. Moses, op. cit., p. 138.

95. Uhde, op. cit., p. 63.

96. Tomašević, op. cit., pp. 108–109.

97. Janis, op. cit., pp. 32–33.

98. Moses, op. cit., p. 133.

99. Janis, op. cit., p. 189.

100. Tomašević, op. cit., p. 105.

101. Arkus, op. cit., p. 73.

List of Illustrations

1. **Henri Rousseau.** Flowers in a Vase. 1909 – 10. Oil on canvas. Signed, lower right. 16 1/8″ x 13 1/16″ (41.2 x 33.1 cm). Vallier 236. Museum of Art, Rhode Island School of Design, Providence, Rhode Island; Gift of Mrs. Murray S. Danforth.

2. **Anonymous New Mexican Artist.** Santa Rosalia. 19th century. Retablo; painted gesso on wood panel. 16½″ x 10⅝″ (41.9 x 27 cm). Private collection.

3. **Anonymous American Artist.** Family Portrait. 19th century. Oil on canvas. 39″ x 43″ (99 x 109.2 cm). Kennedy Galleries, New York.

4. **Louis Vivin.** The Winter Hunt. Ca. 1925. Oil on canvas. Signed, lower left. 19 5/8″ x 24″ (50 x 61 cm). Perls Galleries, New York.

5. **Erastus Salisbury Field.** Portrait of Susan Maynard Shearer. Ca. 1833. Oil on canvas. 40 1/2″ x 34 1/2″ (102.9 x 87.6 cm). Museum of Fine Arts, Springfield, Massachusetts; The Morgan Wesson Memorial Collection.

6. **Anonymous Austrian Artist.** Supplicant in Alpine Chapel with Cow. Ca. 1800. Votive panel; oil on wood. Inscribed "Ex Voto," upper center. 12 1/4″ x 9 3/4″ (31.1 x 24.8 cm).

7. **Anonymous Austrian Artist.** Blacksmith. Iron votive sculpture. Height: 9 7/8″ (25 cm). Private collection. Pig. Iron votive sculpture. Length: 8″ (20.3 cm). Private collection.

8. **Anonymous Austrian Artist.** Woman Being Trampled by Horse. 1839. Votive panel; oil on wood. Inscribed "Ex Voto" and dated, lower left. 10 3/4″ x 7 3/8″ (27.3 x 18.7 cm).

9. **Conrad von Soest.** The Nativity (detail). 1403 – 04. 28 3/4″ x 22″ (73 x 55.9 cm). Town Church, Bad Wildungen (Waldeck), near Cassel, Germany.

10. **Anonymous Austrian Artist.** Nativity. 19th century. Reverse-glass painting. 7 1/2″ x 5 1/4″ (19 x 13.3 cm). Private collection.

11. **Anonymous Austrian Artist.** Last Supper. 19th century. Reverse-glass painting with gold foil. 11 5/8″ x 6 7/8″ (29.5 x 17.4 cm).

12. **Pietro Lorenzetti.** Last Supper (detail). 1320 – 40. Fresco. Lower Church of S. Francesco, Assisi, Italy.

13. **Anonymous French Artist (after Leonardo da Vinci).** The Last Supper. 1800 – 50. Woodcut. 16 15/16″ x 24 3/16″ (40.3 x 61.4 cm). Reprinted from *French Folk Art* by Jean Cuisenier (New York: Kodansha International, 1976).

14. **Anonymous French Artist (after Leonardo da Vinci).** The Last Supper. 1800 – 50. Reverse-glass painting. 33 1/16″ x 23″ (84 x 58.5 cm). Reprinted from *French Folk Art* by Jean Cuisenier (New York: Kodansha International, 1976).

15. **Cologne Master.** The Madonna of the Sweet Pea (center panel). 1400 – 30. 21″ x 13 3/8″ (53.3 x 30.4 cm). Wallraf-Richartz Museum, Cologne, Germany.

16. **Anonymous Austrian Artist.** Virgin and Child. 19th century. Reverse-glass painting with gold foil. 12 3/4″ x 9″ (32.4 x 22.9 cm).

17. **Anonymous New Mexican Artist.** Our Lady of Carmel. Ca. 1780 – 90. Retablo; painted wood panel. 14 3/4″ x 9 5/16″ (37.5 x 23.6 cm). The Brooklyn Museum, Brooklyn, New York; Presented in memory of Dick S. Ramsay.

18. **Anonymous Austrian Artist.** Female Saint. 18th century. Reverse-glass painting with metallic foil. 11″ x 7″ (28 x 17.8 cm).

19. **Anonymous New Mexican Artist (style of José Aragón).** Our Lady of Seven Sorrows. Ca. 1820 – 35. Retablo; painted wood panel. 9 1/2″ x 6 7/8″ (24.1 x 17.5 cm). The Brooklyn Museum, Brooklyn, New York.

20. **José Benito Ortega (attributed).** Our Lady. Late 19th – early 20th century. Bulto; painted gesso on wood. Height: 29″ (73.7 cm). Private collection.

21. **Molleno.** St. Francis Rescuing the Souls of the Damned. Ca. 1810 – 20. Painted buffalo hide. 58 3/8″ x 38 1/16″ (149.2 x 96.7 cm). The Brooklyn Museum, Brooklyn, New York.

22. **Peter Paul Rubens.** Allegory in Honor of the Franciscan Order. 1631 – 32. Oil on canvas. 21 1/8″ x 30 3/4″ (53.6 x 78 cm). John G. Johnson Collection, Philadelphia, Pennsylvania.

23. **Anonymous Santero "A. J."** Our Lady of El Pueblito. Ca. 1820. Retablo; painted wood panel. Reprinted from *Popular Arts of Spanish New Mexico* by E. Boyd (Santa Fe: Museum of New Mexico Press, 1974).

24. **Anonymous Mexican Artist.** True Portrait of the Miraculous Image of Our Lady of the Pueblito. 1776. Copperplate engraving. Reprinted from *Popular Arts of Spanish New Mexico* by E. Boyd (Santa Fe: Museum of New Mexico Press, 1974).

25. **Sarah P. Sherman.** Mourning Picture with Alphabets and Verse. 19th century. Sampler; silk on linen. Signed, left center. 19″ x 18″ (48.2 x 45.7 cm).

26. **Ammi Phillips.** Portrait of Isaac Hunting. 1829. Oil on canvas. Inscribed, top: "Isaac Hunting aged Sixty five Years and ten Months 1829." 30 3/4″ x 25″ (78.1 x 63.5 cm). Hirschl & Adler Galleries, New York.

27. **Ammi Phillips.** Woman in Black Ruffled Dress. Ca. 1837. Oil on canvas. 31″ x 26 1/4″ (78.7 x 66.7 cm). Black 184. Mrs. Jacob M. Kaplan.

28. **William Matthew Prior (attributed).** Baby with Drum. Ca. 1850. Oil on cardboard. 13″ x 10 1/2″ (33 x 26.7 cm). Galerie St. Etienne, New York.

29. **Prior-Hamblen School.** Portrait of a Woman in a Gray Dress. Mid-19th century. Oil on cardboard. 14″ x 10″ (35.5 x 25.4 cm). Galerie St. Etienne, New York.

30. **Edward Savage.** The Savage Family. Ca. 1779. Oil on canvas. 24 3/4″ x 34 1/2″ (62.9 x 87.6 cm). Worcester Art Museum, Worcester, Massachusetts; 1964.7, Gift of William A. Savage.

31. **Edward Savage.** The Washington Family. 1798. Stipple engraving. 18 7/16″ x 24 1/2″ (46.8 x 62.2 cm). Worcester Art Museum, Worcester, Massachusetts; Goodspeed Collection.

32. **Anonymous American Artist.** The George Washington Family (after the painting of this subject by Edward Savage). Ca. 1800. Oil on canvas. 20″ x 27″ (50.8 x 68.6 cm). Galerie St. Etienne, New York.

33. **Anonymous American Artist.** The Washington Family (after the painting of this subject by Edward Savage). Ca. 1800. Oil on canvas. 84 3/4″ x 38 1/2″ (215.2 x 97.8 cm). Hirschl & Adler Galleries, New York.

34. **Mathew Brady.** General Winfield Scott Addressing Lincoln and His Cabinet. Ca. 1860. Composite photograph. Reprinted from

Mathew Brady and His World by Dorothy Meserve Kunhardt and Philip B. Kunhardt, Jr. (New York: Time-Life Books, 1977).

35. **Anonymous American Artist.** President Abraham Lincoln and His First Cabinet (after a photograph by Mathew Brady). Ca. 1860. Oil on cardboard. Inscribed, verso: "This picture of President Lincons (!) first cabinet was painted by a young Soldier and presented to me. Isabella D. Rees. Washington, D.C. January 1864." 11 7/8" x 15 3/4" (30.2 x 40 cm). Galerie St. Etienne, New York.

36. **George Henry Durrie (attributed).** Church, Westfield Farms. Ca. 1850 – 1900. Oil on canvas. 21" x 27 1/2" (53.4 x 69.9 cm). Museum of Fine Arts, Springfield, Massachusetts; James Philip Gray Collection.

37. **George Henry Durrie (after).** Winter Sunday in Olden Times. 1875. Lithograph. Published by F. Gleason, Boston. 15 1/2" x 21 1/2" (39.3 x 54.6 cm). Library of Congress, Washington, D.C.

38. **Addison Kingsley.** Winter Landscape with Yellow Barn. Ca. 1860. Oil on canvas. Signed, lower right. 30" x 39" (76.2 x 99.1 cm). Galerie St. Etienne, New York.

39. **George Henry Durrie (after).** Home to Thanksgiving. 1867. Lithograph. Published by Currier and Ives, New York. 14 3/4" x 25 1/8" (37.5 x 63.8 cm). Library of Congress, Washington, D.C.

40. **Anna Mary Robertson Moses.** Home for Thanksgiving. Before 1940. Oil on canvas. Signed, lower left. 10 1/2" x 12 1/2" (26.6 x 31.7 cm). Kallir 34. Private Collection.

41. **Anna Mary Robertson Moses.** The Spring in Evening. 1947. Oil and tempera on Masonite. Signed, lower left. 27" x 21" (68.5 x 53.3 cm). Kallir 706.

42. **Dominique Lagru.** Spring. 1952. Oil on canvas. Signed, dated and titled, lower center. 19 5/8" x 25 1/2" (49.8 x 64.8 cm). Galerie St. Etienne, New York.

43. **Henri Rousseau.** Study for Notre Dame. 1909. Oil on canvas. 8 1/16" x 11" (20.5 x 28 cm). Vallier 228b. On loan from Mrs. Henry D. Sharpe to the Museum of Art, Rhode Island School of Design, Providence, Rhode Island.

44. **Henri Rousseau.** Notre Dame. 1909. Oil on canvas. Signed and dated, lower right. 13" x 15 7/8" (33 x 40.2 cm). The Phillips Collection, Washington, D.C.

45. **Henri Rousseau.** Rainy Morning. Ca. 1886. Oil on canvas. Signed, lower left. 13 3/4" x 10 1/4" (35 x 26 cm). Private collection.

46. **Louis Vivin.** The Gate of St. Denis, Paris. Ca. 1935. Oil on canvas. Signed, lower left. 25 1/2" x 31 7/8" (64.8 x 81 cm). Perls Galleries, New York.

47. **André Bauchant.** The Farmers' Rest. 1929. Oil on canvas. Signed and dated, lower right. 34" x 44 1/2" (86.4 x 113 cm). Perls Galleries, New York.

48. **Séraphine Louis.** Flowers. Ca. 1920 – 30. Oil on canvas. Signed twice, upper right. 36" x 28 3/4" (91.5 x 73 cm). Private collection.

49. **Dominique Lagru.** Self-portrait. 1956. Tempera on fiber board. Signed and dated, lower right. 21 1/2" x 18" (54.1 x 45.7 cm).

50. **Dominique Lagru in His Little Studio.** November 1957. Photograph.

51. **Jules Lefranc.** Moulin de la Galette, Rue Girardon, Paris. Before 1957. Oil on canvas, mounted on heavy cardboard. Signed, lower left. Signed and titled, verso. 18" x 10 5/8" (45.7 x 27 cm). Galerie St. Etienne, New York.

52. **Olof Krans.** Olson Farm, Sweden, 1900. 1900. Oil on canvas. Signed and dated, lower right. 16 3/4" x 22 1/2" (42.5 x 57.2 cm). Kennedy Galleries, New York.

53. **John Kane.** Junction Hollow. 1932. Oil on canvas. Signed and dated, lower right. 19 1/4" x 26 3/4" (48.9 x 68 cm). Arkus 134. The Whitney Museum of American Art, New York; Gift of Mr. and Mrs. B. and Allan Roos in memory of Robert M. Benjamin, 1966; 66.57.

54. **John Kane.** The Monongahela River Valley. 1931. Oil on canvas. Signed and dated, lower left. 28" x 35" (71.1 x 88.9 cm). Arkus 130. The Metropolitan Museum of Art; Bequest of Miss Adelaide Milton DeGroot (1876 – 1967), 1967.

55. **Horace Pippin.** Cabin in the Cotton III. 1944. Oil on canvas. Signed, lower right. 23" x 29 1/4" (58.4 x 74.3 cm). Rodman 78. Roy R. Neuberger.

56. **Anna Mary Robertson Moses.** 1949. Photograph by Otto Kallir.

57. **Anna Mary Robertson Moses.** The Burning of Troy in 1862. 1943. Oil and tempera on Masonite. Signed, lower right. 18" x 29 1/4" (45.7 x 74.3 cm). Kallir 298.

58. **The Bridge that Started the Great Fire of 1862.** Newspaper clipping, 1939.

59. **The Hands of Grandma Moses.** Photograph by Otto Kallir.

60. **Anna Mary Robertson Moses.** Cambridge Valley in Winter. 1944. Signed, lower right. 23 3/4" x 29 3/4" (60.4 x 75.5 cm). Kallir 428.

61. **Fred E. Robertson.** Black River Thaw (The Blizzard). 1945. Oil on Masonite. Signed and dated, lower left. 24" x 30" (61 x 76.2 cm). Private collection.

62. **Clara McDonald Williamson.** Chicken for Dinner. 1945. Oil on canvas. Signed, lower right. 22 1/2" x 30 1/4" (57.1 x 76.8 cm). Valley House Gallery, Dallas, Texas.

63. **Professor Krsto Hegedušić.** Hlebine, 1962. Photograph.

64. **Ivan Generalić's Worktable and Tools.** Photograph.

65. **Ivan Generalić.** Hlebine, 1962. Photograph.

66. **Dragan Gaži.** Hlebine, 1962. Photograph.

67. **Dragan Gaži.** The Black Horse. 1962. Reverse-glass painting. Signed and dated, lower right. 19 3/8" x 23 3/8" (49.2 x 59.4 cm).

68. **Ivan Lacković.** Yellow Flowers. 1965. Reverse-glass painting. Signed and dated, lower right. 19" x 11 5/8" (48.3 x 29.5 cm).

69. **Ivan Rabuzin.** Red Vase. 1964. Oil on canvas. Signed and dated, lower right. 25 1/2" x 19 5/8" (64.8 x 49.8 cm).

70. **Ivan Rabuzin.** Flowers. 1964. Oil on canvas. Signed and dated, lower left. 39 1/4" x 28 3/4" (99.7 x 73 cm).

71. **Ivan Rabuzin.** The Forest. 1964. Oil on canvas. Signed and dated, lower right. 19 3/4" x 25 5/8" (50.2 x 65.1 cm).

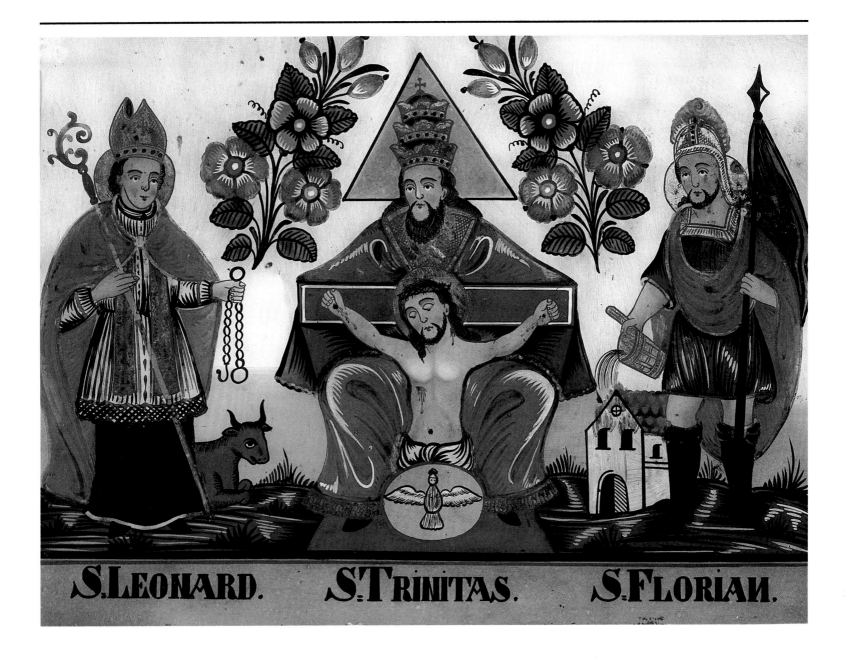

Plate 1. **Anonymous Austrian Artist.** The Holy Trinity with Saints Leonard and Florian. 19th century.

Plate 2. **Anonymous Austrian Artist.** Joseph and Mary. 19th century.

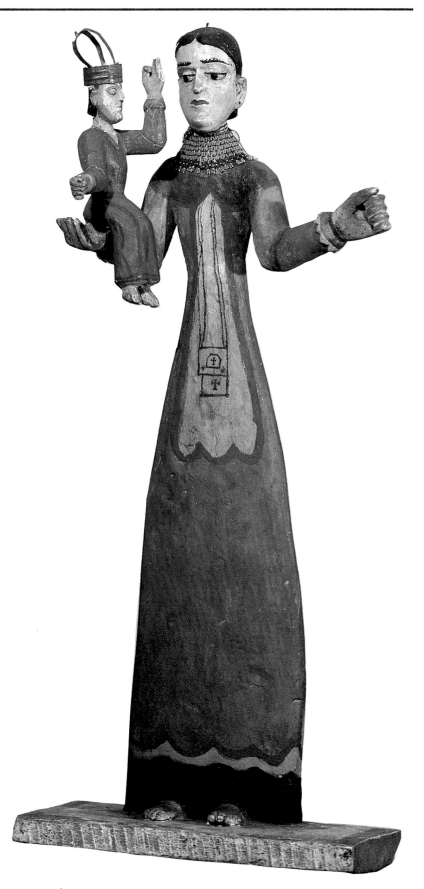

Plate 3. **José Benito Ortega (attributed).** Our Lady of Mt. Carmel. Late 19th century.

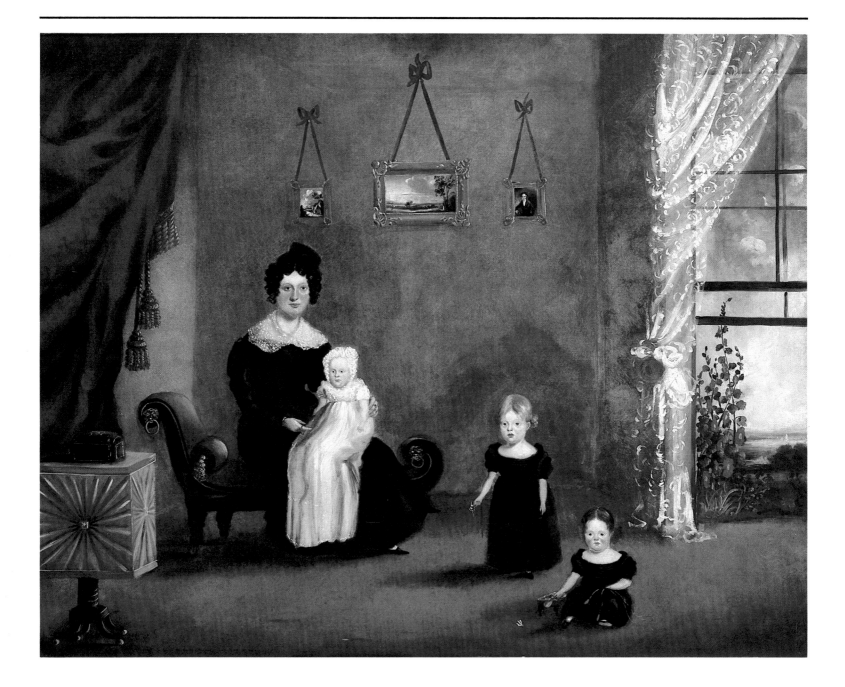

Plate 4. **Anonymous American Artist.** Greek Revival Interior. Ca. 1830.

Plate 5. **Erastus Salisbury Field.** Mine Eyes Have Seen the Glory. Ca. 1880.

Plate 6. **Joseph Whiting Stock.** Portrait of Mary Abba Woodworth. 1837.

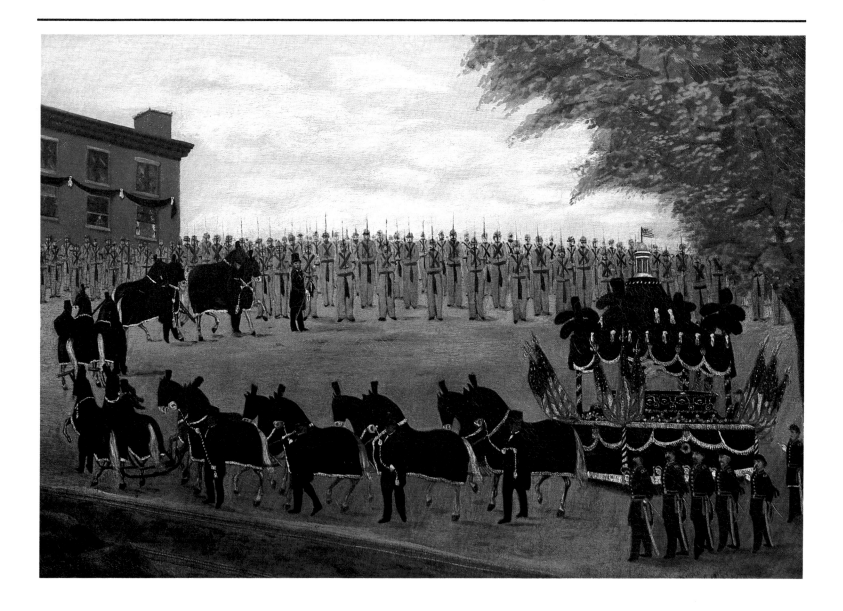

Plate 7. **S. F. Milton.** President Abraham Lincoln's Funeral Procession. 1870.

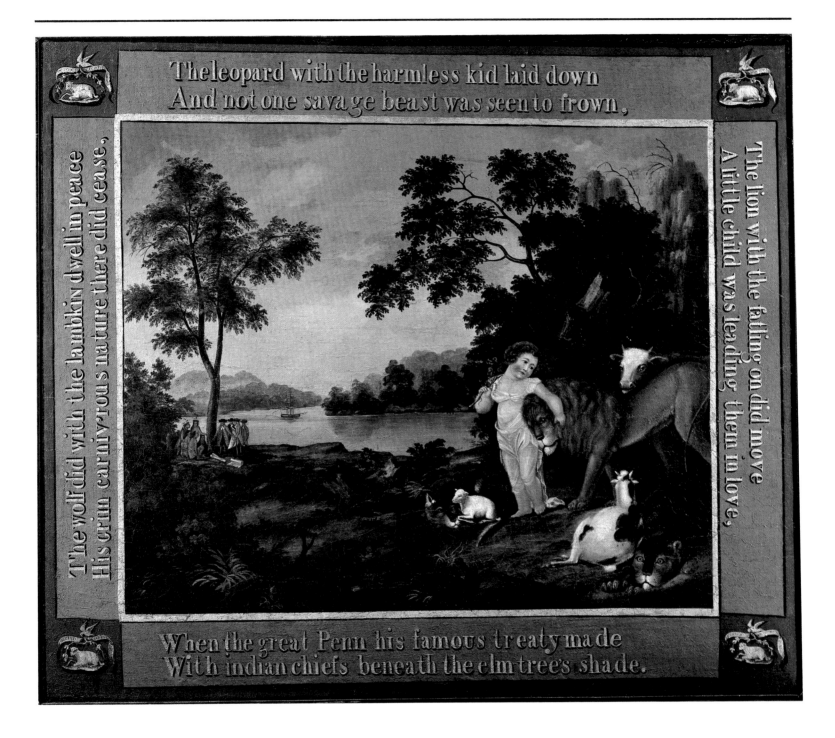

The leopard with the harmless kid laid down
And not one savage beast was seen to frown,

The wolf did with the lambkin dwell in peace
His grim carnivrous nature there did cease,

The lion with the fatling on did move
A little child was leading them in love,

When the great Penn his famous treaty made
With indian chiefs beneath the elm tree's shade.

Plate 8. **Edward Hicks.** Peaceable Kingdom. 1826.

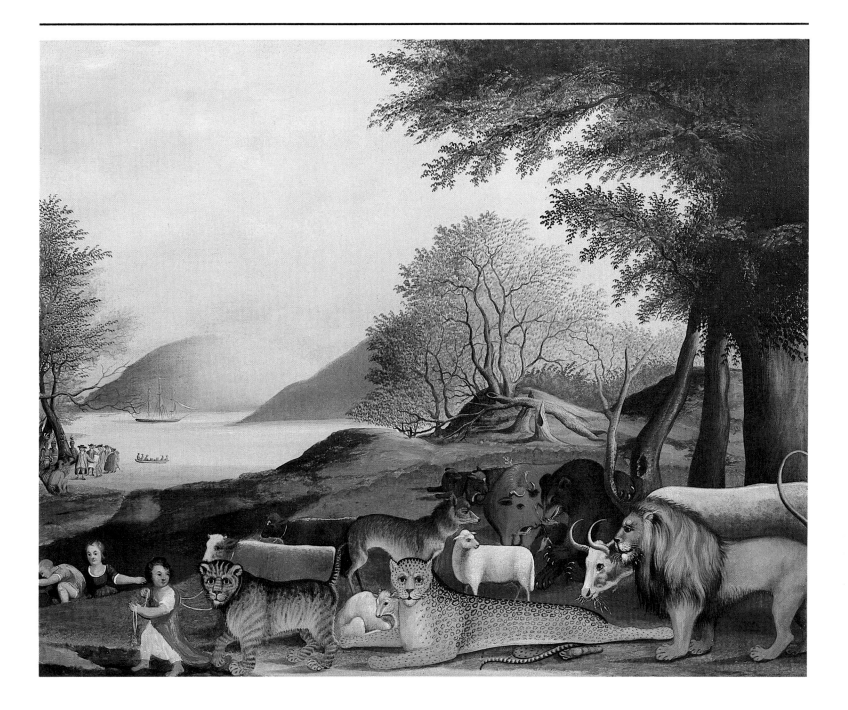

Plate 9. **Edward Hicks.** The Peaceable Kingdom. 1849.

Plate 10. **Henri Rousseau.** The Banks of the Oise. 1905.

Plate 11. **Henri Rousseau.** Exotic Landscape. 1910.

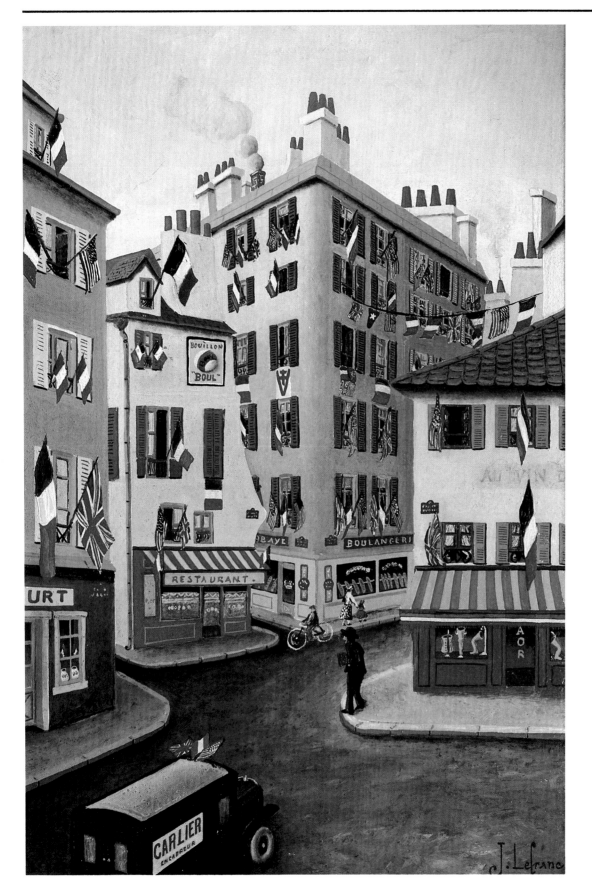

Plate 12. **Jules Lefranc.** After the Liberation. 1943 – 44.

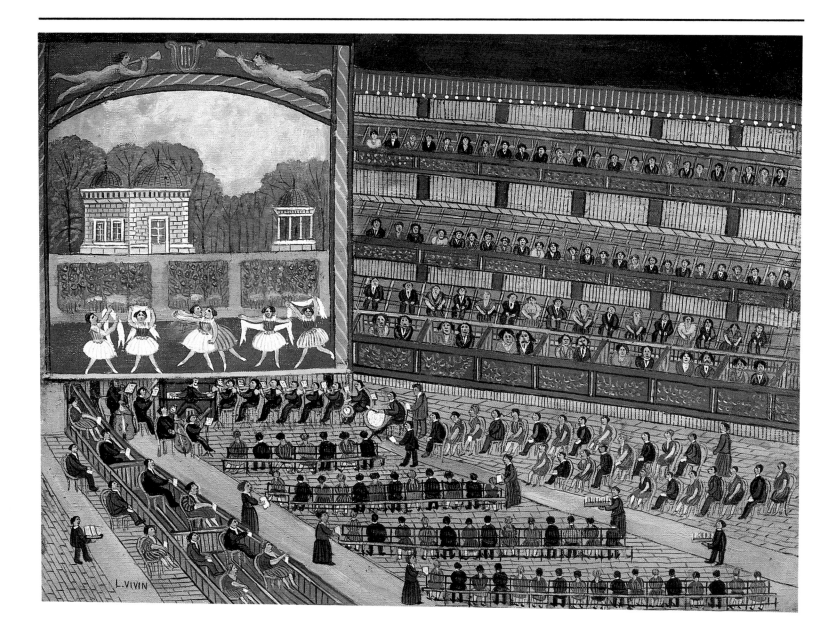

Plate 13. **Louis Vivin.** At the Ballet. Ca. 1925.

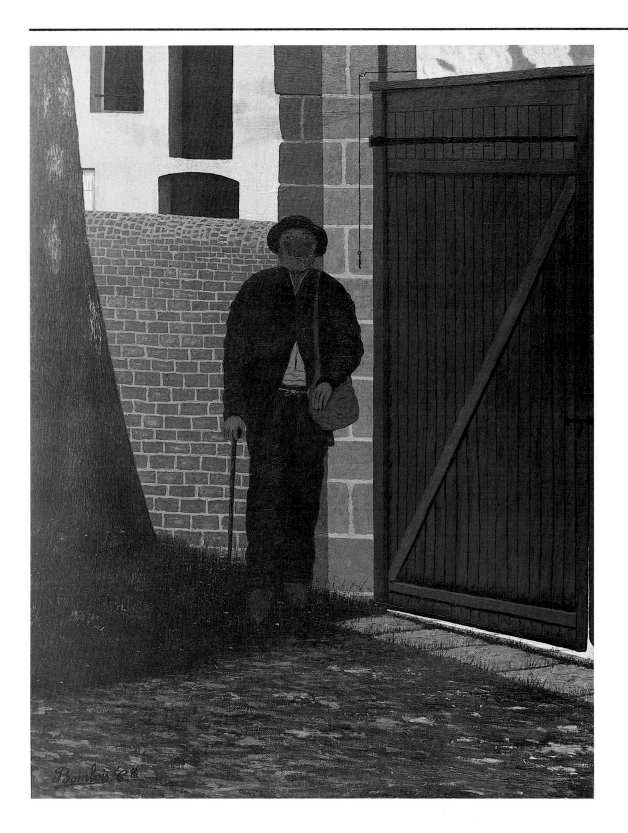

Plate 14. **Camille Bombois.** Old Man at the Gate. Ca. 1930.

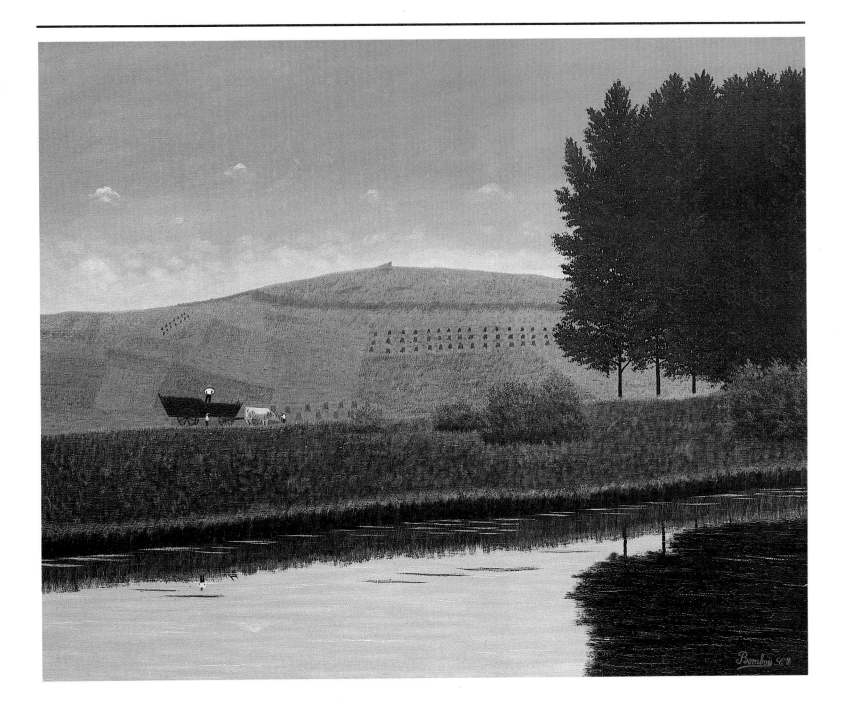

Plate 15. **Camille Bombois.** End of the Harvest in Champagne. Ca. 1930.

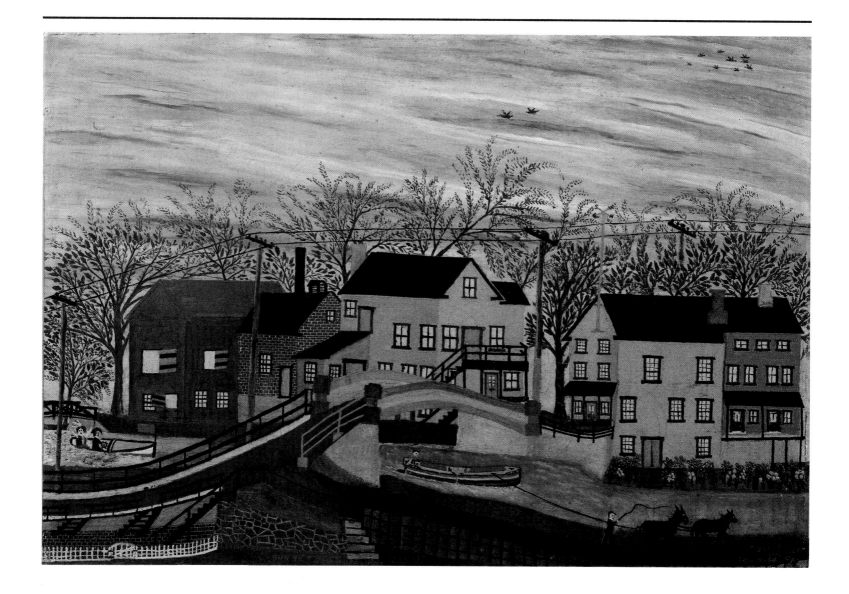

Plate 16. **Joseph Pickett.** Lehigh Canal, Sunset, New Hope, Pa. Ca. 1915 – 18.

Plate 17. **John Kane.** Across the Strip. 1929.

Plate 18. **Anna Mary Robertson Moses.** Hoosick Valley. 1944.

Plate 19. **Anna Mary Robertson Moses.** White Birches. 1961.

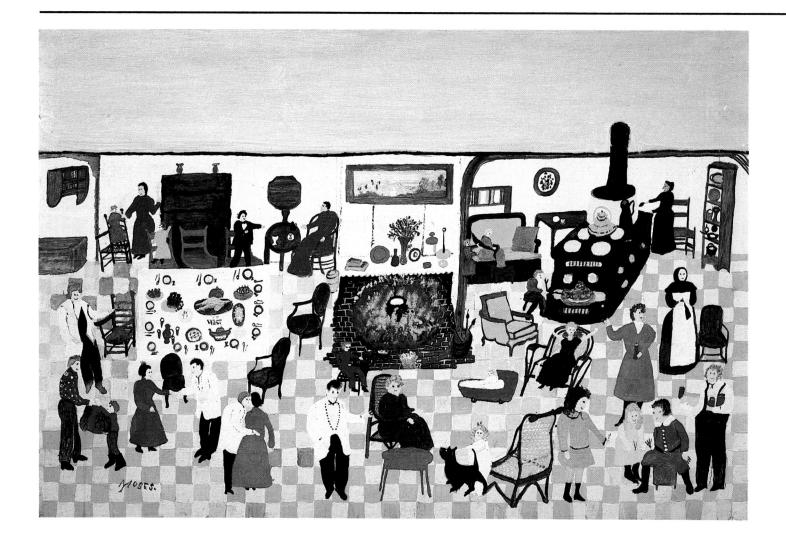

Plate 20. **Anna Mary Robertson Moses.** Old Times. 1957.

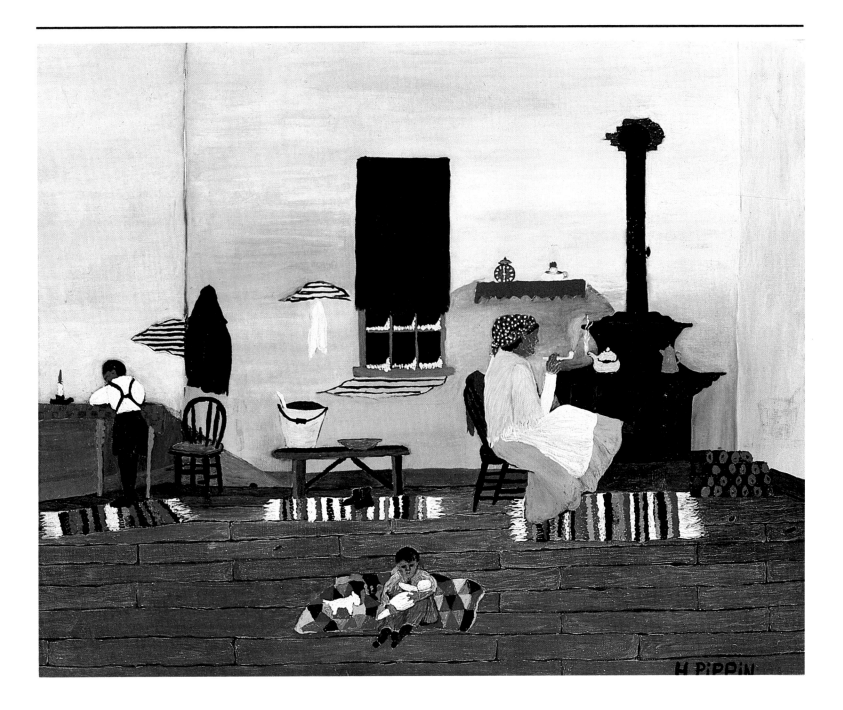

Plate 21. **Horace Pippin.** Interior. 1944.

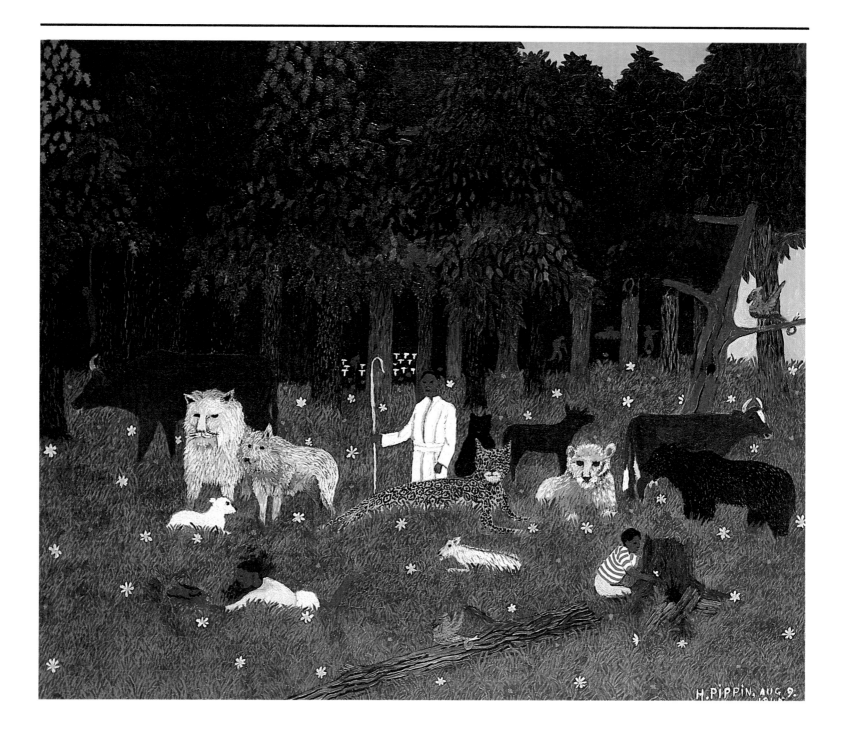

Plate 22. **Horace Pippin.** Holy Mountain III. 1945.

Plate 23. **Morris Hirshfield.** Tiger. 1940.

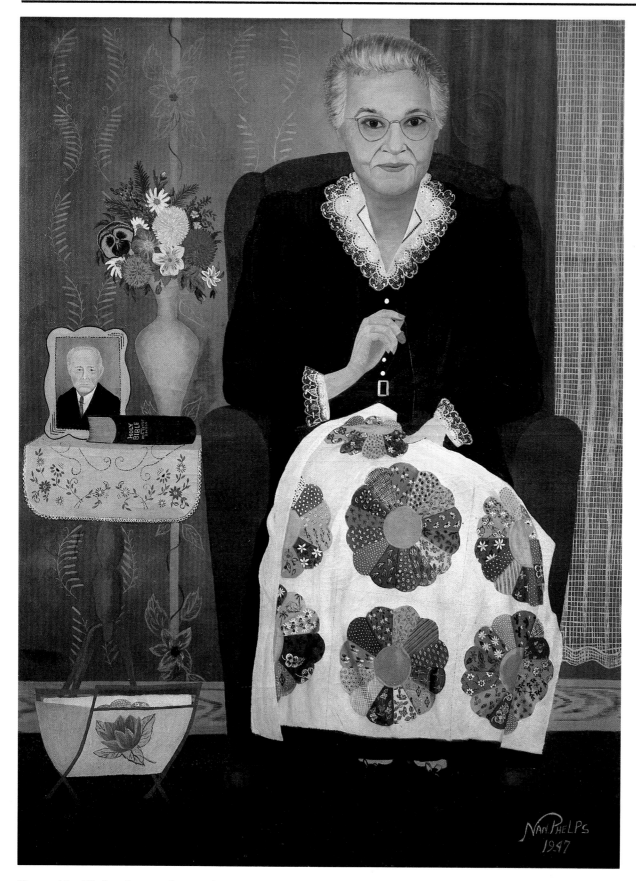

Plate 24. **Nan Phelps.** Portrait of My Mother Making a Quilt. 1947.

Plate 25. **Nan Phelps.** Riverfront Stadium: Phillies and Reds. 1978–79.

Plate 26. **Dragan Gaži.** Harvest in the Forest. 1967.

Plate 27. **Ivan Generalić.** River Landscape. 1964.

Plate 28. **Stjepan Stolnik.** Vintage. 1962.

Plate 29. **Dragan Gaži.** Umbrella Maker. 1962.

List of Color Plates

1. **Anonymous Austrian Artist.** The Holy Trinity with Saints Leonard and Florian. 19th century. Reverse-glass painting with gold foil. Inscribed, bottom: "S.Leonard. S.Trinitas. S.Florian." 11 13/16″ x 15 7/8″ (30 x 40.3 cm).

2. **Anonymous Austrian Artist.** Joseph and Mary. 19th century. Reverse-glass painting. 12 3/4″ x 8 13/16″ (32.4 x 22.4 cm).

3. **José Benito Ortega (attributed).** Our Lady of Mt. Carmel. Late 19th century. Bulto; painted gesso on wood. Height: 28 3/4″ (73 cm). Private collection.

4. **Anonymous American Artist.** Greek Revival Interior. Ca. 1830. Oil on canvas. 34 1/2″ x 44″ (87.6 x 101.8 cm). Galerie St. Etienne, New York.

5. **Erastus Salisbury Field.** Mine Eyes Have Seen the Glory. Ca. 1880. Oil on canvas. 34 1/2″ x 46″ (87.6. x 116.8 cm). Museum of Fine Arts, Springfield, Massachusetts; The Morgan Wesson Memorial Collection.

6. **Joseph Whiting Stock.** Portrait of Mary Abba Woodworth. 1837. Oil on canvas. 48 1/4″ x 33 1/4″ (122.5 x 84.5 cm). Museum of Fine Arts, Springfield, Massachusetts; Gift of Dr. William Barri Kirkham.

7. **S. F. Milton.** President Abraham Lincoln's Funeral Procession. 1870. Oil on canvas. Indistinctly signed and dated, lower right. 27″ x 39″ (68.6 x 99.1 cm). Private collection.

8. **Edward Hicks.** Peaceable Kingdom. 1826. Oil on canvas. With rhymed border inscription. The back of the painting was photographed prior to relining, recording the inscription: "Edward Hicks, Painter to his dear Cousin Sarah Hicks 4mo 1st 1826 New York." 32 1/8″ x 38 1/8″ (81.6 x 96.8 cm). Photograph courtesy Christie, Manson & Woods International, New York.

9. **Edward Hicks.** The Peaceable Kingdom. 1849. Oil on canvas. 24″ x 30 1/4″ (61 x 76.8 cm). Private collection.

10. **Henri Rousseau.** The Banks of the Oise. 1905. Oil on canvas. Signed, lower left. 18″ x 22″ (45.7 x 55.9 cm). Vallier 173. Smith College Museum of Art, Northampton, Massachusetts; Purchased 1939.

11. **Henri Rousseau.** Exotic Landscape. 1910. Oil on canvas. Signed and dated, lower right. 50 3/4″ x 64″ (129 x 162.6 cm). Vallier 252. The Norton Simon Foundation, Pasadena, California.

12. **Jules Lefranc.** After the Liberation. 1943–44. Oil on Masonite. Signed, lower right. Signed and titled, verso. 21 1/4″ x 14 3/8″ (54 x 36.5 cm).

13. **Louis Vivin.** At the Ballet. Ca. 1925. Oil on canvas. Signed, lower left. 18″ x 24″ (46 x 61 cm). Perls Galleries, New York.

14. **Camille Bombois.** Old Man at the Gate. Ca. 1930. Oil on canvas. Signed, lower left. 25 1/2″ x 19 5/8″ (64.8 x 49.8 cm). Perls Galleries, New York.

15. **Camille Bombois.** End of the Harvest in Champagne. Ca. 1930. Oil on canvas. Signed, lower right. 31 7/8″ x 39 1/4″ (81 x 99.7 cm). Sigrid Balmer.

16. **Joseph Pickett.** Lehigh Canal, Sunset, New Hope, Pa. Ca. 1915–18. Oil on canvas. Signed, lower right, and titled, lower left. 24″ x 34″ (61 x 86.4 cm). Estate of Otto Kallir.

17. **John Kane.** Across the Strip. 1929. Oil on canvas. Signed and dated, lower right. 32 1/4″ x 34 1/4″ (82 x 87 cm). Arkus 121. The Phillips Collection, Washington, D.C.

18. **Anna Mary Robertson Moses.** Hoosick Valley. 1944. Oil and tempera on canvas. Signed, lower left. 36″ x 45″ (91.5 x 114.3 cm). Kallir 341. Hammer Galleries, New York.

19. **Anna Mary Robertson Moses.** White Birches. 1961. Oil and tempera on Masonite. Signed, lower center. 16″ x 24″ (40.6 x 61 cm). Kallir 1489. Private collection.

20. **Anna Mary Robertson Moses.** Old Times. 1957. Oil and tempera on Masonite. Signed, lower left. 16″ x 24″ (40.6 x 61 cm). Kallir 1296. Private collection.

21. **Horace Pippin.** Interior. 1944. Oil on canvas. Signed, lower right. 24 1/8″ x 29 3/4″ (61.3 x 75.5 cm). Rodman 81. Mr. and Mrs. Meyer P. Potamkin.

22. **Horace Pippin.** Holy Mountain III. 1945. Oil on canvas. Signed and dated, lower right. 24 1/4″ x 30 1/4″ (64.6 x 76.8 cm). Rodman 84. Hirshhorn Museum and Sculpture Garden, Smithsonian Institution, Washington, D.C.

23. **Morris Hirshfield.** Tiger. 1940. Oil on canvas. Signed and dated, lower right. 28″ x 39 7/8″ (71.1 x 101.3 cm). The Museum of Modern Art, New York; Abby Aldrich Rockefeller Fund, 1941.

24. **Nan Phelps.** Portrait of My Mother Making a Quilt. 1947. Oil on canvas. Signed and dated, lower right. 59 5/8″ x 44 1/2″ (151.5 x 113 cm).

25. **Nan Phelps.** Riverfront Stadium: Phillies and Reds. 1978–79. Oil on Masonite. Signed and dated, lower right. 34″ x 48″ (86.3 x 121.9 cm).

26. **Dragan Gaži.** Harvest in the Forest. 1967. Reverse-glass painting. Signed twice and dated, lower right. 19 3/8″ x 21 3/8″ (49.2 x 51.8 cm).

27. **Ivan Generalić.** River Landscape. 1964. Reverse-glass painting. Signed and dated, lower left. 21 3/4″ x 25 3/4″ (55.2 x 65.4 cm).

28. **Stjepan Stolnik.** Vintage. 1962. Reverse-glass painting. Signed and dated, lower right. 16″ x 23 1/4″ (42 x 60 cm).

29. **Dragan Gaži.** Umbrella Maker. 1962. Reverse-glass painting. Signed and dated, lower right. 15 1/2″ x 14″ (39.4 x 35.5 cm).

Biographical Index

of self-taught artists whose work is discussed or reproduced herein

A. J. (Active ca. 1820)

Page 20; Figure 23.

A distinctive series of New Mexican retablos and bultos, executed in thinly applied paint on a gritty gesso ground, suggests common authorship. A single initialed piece provides the only clue to A. J.'s identity, and another, dated 1822, gives a general idea of his active period.

José Aragón (Active 1820 – 1835)

Figure 19.

Aragón was born in Spain and came to New Mexico in 1820. His santos show the influence of European engravings and frequently carry poems, attesting to his literacy. The inscriptions on some of his pieces indicate that he operated from a sculpture shop. In 1837, fearing that annexation of New Mexico by the United States was imminent, Aragón moved further south along the Rio Grande.

André Bauchant (1873 – 1958)

Pages 44 – 45; Figure 47.

Bauchant was born near Tours, France, in Château-Renault, and spent most of his early years working as a farm hand. From 1914 to 1918 he served with the French army. During this time he made a series of panoramic sketches of the Battle of the Marne which were exhibited in the 1921 Salon d'Automne. He developed an interest in literature and history, and many of his earlier works, such as *The Battle of Thermopylae,* are of classical and historical subjects. In 1927 he designed the sets and costumes for Diaghilev's production of Stravinsky's *Apollon Musagète.* His later paintings show a change in subject matter to flowers, birds, scenes of peasant life, and landscapes.

Camille Bombois (1883 – 1970)

Pages 42 – 44; Plates 14, 15.

Bombois was born in Venarey-les-Laumes in southern France. He left school to work on a farm at age twelve and began drawing four years later. By 1907 he had moved to Paris, where he worked on subway construction. After taking a job on the night shift at a newspaper plant, he found more time to paint..Bombois served in the First World War for three years, then in 1922 began painting full-time. He displayed his works on the sidewalks at first, then through art dealers. Later his pictures sold well enough to enable him to buy a house in the country.

George Henry Durrie (1820 – 1863)

Page 33; Figures 36, 37, 39.

Durrie was born in New Haven, Connecticut, where he spent most of his life. His earliest sketches date from his teens, already showing a strong predilection for landscape subjects. From 1839 to 1841 he studied portrait painting with Nathaniel Jocelyn in New Haven. During this time he began traveling for portrait and decorative commissions. He married Sarah Perkins in 1841 in Bethany, Connecticut. Durrie had several studios during his life, including one in New York City, opened in 1857. As his career prospered, he exhibited numerous times in both New Haven and New York. In 1861 Currier and Ives published the first two of many lithographs done after his landscapes.

Erastus Salisbury Field (1805 – 1900)

Pages 26 – 28; Figure 5; Plate 5.

Field and his twin sister were born in Leverett, Massachusetts. Their parents, impressed by the boy's impromptu sketches, sent him to New York in 1824 to study with the renowned painter Samuel F. B. Morse. His lessons terminated rather abruptly, and by the spring of 1825 he was back in Massachusetts. A little over a year later, he began traveling, roaming through central Massachusetts and eastern New

York in search of portrait commissions. In 1831 he married Phebe Gilmur in Ware, Massachusetts. He continued to work the Connecticut – Massachusetts area, and in the 1840s returned to New York City. There he stayed, occasionally exhibiting his work at the American Institute, until he was called back to Massachusetts in 1848. He worked in both Palmer and Sunderland, finally settling in the latter village after the death of his wife in 1859. *The Monument of the American Republic* (1876), one of a number of allegorical paintings done by Field in his last years, must be considered his masterpiece, due both to its large size and its complexity.

Dragan Gaži (Born 1930)

Page 58; Figures 66, 67; Plates 26, 29.

Gaži, like Ivan Generalić, was born in Hlebine, Yugoslavia, and began drawing while still a child. Generalić first saw his work in 1947 and subsequently taught him the technique of painting on glass. Gaži continued to lead the life of a farmer, painting only in his spare time.

Ivan Generalić (Born 1914)

Page 56; Figures 64, 65; Plate 27.

Generalić was born in the village of Hlebine, in Yugoslavia's Croatian province. From childhood on, he frequently sketched both village and imaginary scenes. He was discovered at the age of sixteen by the artist Krsto Hegedušić. A founding member of the artistic group "Earth," Hegedušić was interested in finding native talent in order to prove that an "art of the people" could provide a valid alternative to modernism. As a result of his meeting with Hegedušić, Generalić became his student and then, along with other painters, the center of a group known as the "Hlebine School." He still lives in his native village, working as both a painter and a farmer.

Edward Hicks (1780 – 1849)

Pages 31 – 32; Plates 8, 9.

Hicks was born in Attleborough (now Langhorne), Pennsylvania, of old New England Puritan stock. His family's Tory connections led to trouble after the Revolutionary War, and the boy was sent to live with the Twinings, a Quaker family. Later in life, Hicks became a Quaker minister. In 1803 he married Sarah Worstall, and eight years later he settled his family in Newtown, Pennsylvania. He successfully combined his duties as a craftsman, an artist, and a preacher throughout the remainder of his life.

Morris Hirshfield (1872 – 1946)

Page 50; Plate 23.

Hirshfield was born in Lithuania where, as a young boy, he created an impressive sculpture for his local synagogue. He immigrated to the United States at the age of eighteen, and worked in a coat factory in New York. After marrying in his late thirties, Hirshfield started his own business, manufacturing first coats and later slippers. His retirement in 1937, after a protracted illness, prompted him to begin painting seriously. His first one-man exhibition was held at the Museum of Modern Art in 1943.

John Kane (1860 – 1934)

Pages 48 – 49; Figures 53, 54; Plate 17.

Born in West Calder, Scotland, Kane immigrated to Braddock, Pennsylvania, with his family at the age of nineteen. He worked as a laborer most of his life in both Scotland and the United States, but in 1890 he started sketching. Forced to give up more strenuous work after losing his left leg in a train accident in 1891, Kane made a living through such jobs as house painting, and enlarging and coloring photographs. In

1897 he married Maggie Halloran, who left him when he began drinking heavily after the death of his infant son in 1904. As an itinerant worker, Kane continued to paint but always lacked either time or money to attend art school. In 1927 the Carnegie International exhibition accepted one of his paintings, and his works continued to be collected and exhibited in Pittsburgh and New York.

Addison Kingsley (Active ca. 1860)
Page 33; Figure 38.

Other than one or two landscapes, no record survives of Kingsley or his work. He appears to have been active in the United States around the time of the Civil War.

Olof Krans (1838 – 1916)
Page 47; Figure 52.

While still a child, Krans emigrated with his family from Salja, Sweden, to Bishop Hill, Illinois. At Bishop Hill, a utopian Swedish commune begun by the religious dissenter Erik Jansson, Krans was assigned to the paint shop, where he learned how to paint and decorate buildings. He served for one year as an infantryman during the Civil War, then resumed his career as a painter in the Bishop Hill area. He also operated a portable photographic gallery. In 1894 a painting Krans had done on a community theater curtain received such a positive reception that he was induced to turn to painting as a full-time occupation. He painted historical scenes, among them a series documenting the activities of the Bishop Hill community, portraits, and other paintings adapted from illustrations and photographs.

Ivan Lacković (Born 1932)
Figure 68.

Born in the Yugoslavian village of Batinska, Lacković was initially a forester and gardener by profession. He found an outlet for his artistic instincts by copying religious pictures. After serving in the army, he moved to Zagreb in 1957, where he worked in the post office. It was in Zagreb that he first came in contact with the Gallery of Primitive Art and its spiritual father, Krsto Hegedušić.

Dominique Lagru (1873 – 1960)
Page 46; Figures 42, 49, 50.

Born in Perrecy-les-Forges, France, Lagru became a shepherd at age twelve and later a coal miner. After serving in the First World War, he became involved in the labor movement. He did not begin to paint until he was seventy-six years old. Most striking are his paintings of prehistoric landscapes filled with the dinosaurs he had seen in books and at the natural history museum. In 1951 he had his first one-man show in Paris.

Jules Lefranc (1887 – 1972)
Page 46; Figure 51; Plate 12.

Lefranc was born in Laval, France, where he later owned a hardware store. In 1902, at the suggestion of Claude Monet, he first tried his hand at painting. However, it was not until many years later, in 1928, that he gave up his original profession to paint full-time. His first one-man show was held in 1938 in Paris, where he lived for some time, and was followed by exhibitions in England, France, and the United States.

Séraphine Louis (Séraphine de Senlis) (1864 – 1942)
Page 46; Figure 48.

Séraphine was born in France at Assy, where she spent her youth tending farm animals. Later she became a domestic servant in the town of Senlis. The German art dealer Wilhelm Uhde first noticed her

paintings in 1912 but did not actively encourage her until after the First World War. He helped her by providing art supplies and, especially, the very large canvases she craved. Always a little eccentric, her religious zeal and paranoiac work habits gradually developed into a full-scale psychosis. She died in the insane asylum at Clermont.

S. F. Milton (19th century)
Page 31; Plate 7.

Milton, an American painter, is known only from his signature on a single work. He is thought to have been black.

(Antonio?) Molleno (Active 1804 – 1845)
Figure 21.

Molleno must have been an extremely popular santero, judging from the wide distribution of his works in the New Mexico area. Although his first known santos date from 1804, their proficiency suggests that he began earlier. He completed two retablos for a church in Taos before 1818, one of which is the largest in New Mexico. His early pieces show the influence of other artists, but by 1828 he had developed his own style. Before the discovery of his name he was known as the "chili painter," because leaf forms resembling those of the chili plant may be found in certain of his works.

Anna Mary Robertson (Grandma) Moses (1860 – 1961)
Pages 50 – 52; Figures 40, 41, 56, 57, 59, 60; Plates 18, 19, 20.

Moses was born in Greenwich, New York. As a young child she attended school part-time while working on her father's farm until she became a "hired girl" on a neighbor's farm at age twelve. Her father encouraged his children to draw by giving them drawing paper; even at this early age the artist preferred to depict landscapes. She married Thomas Moses in 1887 and moved with him to Virginia. They had ten children, of whom five lived. In 1905 the family returned to New York, where Thomas died in 1927. As Moses became less able to perform strenuous household work, she turned first to embroidery and then, with the onset of arthritis, to painting. She had her first one-woman show in 1940, and continued to paint and exhibit until her death at the age of 101. She is probably the best known and most popular of all the self-taught artists.

José Benito Ortega (1858 – 1941)
Figure 20; Plate 3.

The last, and most active, of the New Mexican santeros, Ortega began making santos at an early age. According to surviving relatives, the young man was an itinerant who boarded at the homes of those who had commissioned his work. After the death of his wife in 1907, he settled in Raton, abandoning the making of santos for the more secure income of a plasterer. Before being scattered by collectors, his works could be found throughout several counties in New Mexico.

Nan Phelps (Born 1904)
Page 54; Plates 24, 25.

Phelps was one of eleven children born to an impoverished family near London, Kentucky. She first started drawing with crayons in school, which she was forced to leave in the eighth grade to help care for her brothers and sisters. She fled her first husband, a cruel man who had forced her at eighteen to marry him, after three years. With her two children she moved to Hamilton, Ohio, where she met her present husband, Bob Phelps. They were married in 1929 and had three children together. After a two-year correspondence course in design, Phelps began painting in earnest. Her first picture was rejected for exhibition by the Cincinnati Art Museum because its authenticity was doubted.

The museum sent her to the Cincinnati Art Academy to test her abilities, and, after six months, satisfied that her talent was genuine, consented to exhibit three of her paintings. Since then, Phelps's work has received wider attention, and she continues to paint despite her failing health.

Ammi Phillips (1788 – 1865)
Pages 25 – 26; Figures 26, 27.

Phillips, born in Colebrook, Connecticut, began his professional career around 1811. Some of his earliest paintings were discovered near the New York – Massachusetts – Connecticut border, thus earning him the provisional appellation "Border Limner." Like most limners, Phillips traveled extensively. In 1820, seven years after his marriage to Laura Brockway, the couple was living in Troy, New York. Ten years later, at the time of his wife's death, they were in Rhinebeck. Phillips remarried shortly thereafter, and at about the same time (1829 – 38) began to paint in a distinctive new style. The works from this so-called "Kent Period" (named after the town in Connecticut where the paintings first surfaced) were probably executed in New York's Duchess County. Phillips returned to western Massachusetts five years before his death.

Joseph Pickett (1848 – 1918)
Page 47; Plate 16.

Pickett was born in New Hope, Pennsylvania, where he learned carpentry from his father. Until he was forty-five years old, he traveled frequently, operating carnival concessions. When he married in 1893, he settled in New Hope and opened a general store there. Pickett began painting in the late 1890s, first using house paints, then regular artists' supplies. He is known primarily as a landscape artist, though two of his canvases have historical overtones. To date, hardly more than five paintings can be attributed to him.

Horace Pippin (1888 – 1946)
Pages 49 – 50; Figure 55; Plates 21, 22.

Pippin was born in West Chester, Pennsylvania, but his earliest memories were of Goshen, New York, where he spent much of his childhood. His first drawings, done while in school, were Biblical scenes drawn on muslin squares. At fourteen he attempted his first portrait. Pippin began working at a series of unskilled jobs to support his sick mother, who died in 1911. He enlisted in the army in 1917 and was sent to France. He came home the following year, his right arm paralyzed by a sniper's bullet. In 1920 he moved back to West Chester, marrying a widow with a young son. Some nine years later he returned to his artwork, creating a burnt wood panel by balancing a hot poker in his right hand against his knee and moving a piece of wood across the hot tip of the iron with his left hand. This method of scoring the wood eventually helped him to regain strength in the paralyzed arm, and he was able to begin painting again. Pippin's first one-man show was held in West Chester in 1937.

William Matthew Prior (1806 – 1873)
Pages 28 – 29; Figures 28, 29.

Prior was born in Bath, Maine, and began his professional career there in late adolescence. In 1828 he married Rosamond Clark Hamblen, and in the early 1830s the family moved to Portland. From this time on, his brothers-in-law appear to have worked and traveled with him. The Hamblen brothers were skilled at house, sign, and "fancy" painting, but only one, Sturtevant J., is believed to have done portraits. The similarity of his work to Prior's makes positive attribution of many unsigned pieces almost impossible. In 1841 the Prior-Hamblen group moved to Boston. Prior's wife died in 1849, and almost a year later he remarried.

Though Boston remained his base, his travels brought him east through New Bedford and Fall River, and as far south as Baltimore.

Ivan Rabuzin (Born 1920)
Page 58; Figures 69, 70, 71.

Rabuzin was one of nine children born to a miner and his wife in the Yugoslavian village of Ključ. He developed an interest in sketching in his twenties and traveled to the city of Zagreb to attend evening classes in drawing. However, he continued to earn his living working at a furniture factory in a town near his birthplace. It was not until 1958 that he made his first contact with the Gallery of Primitive Art in Zagreb. Four years later he became a professional painter, and his work has since been widely exhibited.

Fred E. Robertson (1878 – 1953)
Page 52; Figure 61.

Robertson, the youngest brother of Grandma Moses, was born on the family farm in Greenwich, New York. Unlike his oldest sister and his eight other siblings, he continued his education beyond district school and eventually graduated from Cornell Agricultural College. He also worked as a hired farm hand until the age of twenty-three and later taught school and worked for the Cornell Farm Bureau. In 1920 Robertson bought a farm in Savannah, New York, where, stimulated by his sister's success, he began his career as a painter at the age of sixty-four. He had his first one-man show in New York in 1945.

Henri Rousseau (1844 – 1910)
Pages 38 – 41; Figures 1, 43, 44, 45; Plates 10, 11.

Rousseau, nicknamed the Douanier, was born in Laval, France. He went to school until joining the army at the age of nineteen. Two years later he moved to Paris where he remained, leaving only for further military service during the Franco-Prussian War. He was married twice, the first time in 1869 to Clémence Boitard, who died in 1884. He outlived his second wife, Joséphine Noury, whom he married in 1899, by about ten years. After retiring from his job in the municipal toll service in 1885, Rousseau devoted himself to painting, bolstering his income by giving music and drawing lessons to local children. In his later years, he exhibited his works with the Salon des Indépendants and the Salon d'Automne. In addition to painting, he is known, on at least two occasions, to have tried his hand at playwriting. During the last decade of his life, he became acquainted with some of the leading figures of the avant-garde, and in 1908 he was honored by a banquet at Picasso's studio. The following year, he was tried for his role in a fraudulent scheme devised by a friend of his. The defense attorney, using one of his paintings as proof of the artist's naïveté, managed to obtain a suspended sentence. Rousseau died in poverty less than two years later, having squandered his meager savings on an unresponsive ladyfriend.

Edward Savage (1761 – 1817)
Pages 29 – 31; Figures 30, 31.

Savage was born in Princeton, Massachusetts, on his family's farm, "Savage Hill." He began his artistic career by copying the work of John Singleton Copley and traveled to London to study. In 1795, a year after his return, he moved to Philadelphia, opening a gallery there a year later. He left Philadelphia for New York in 1801, and in 1812 he moved to Boston where he operated a small museum.

Joseph Whiting Stock (1815 – 1855)
Page 28; Plate 6.

Stock, born in Springfield, Massachusetts, had an uneventful childhood until the age of eleven, when an accident left him crippled below the waist. On the advice of his physician, he began to study art in 1832,

and within four years, aided by a specially designed wheelchair, he was able to begin his career as an itinerant portrait painter. He was active in Connecticut, Rhode Island, and eastern Massachusetts before returning to Springfield in 1844. Ill health continued to plague him all his life. In 1839 he was badly burned when heating some varnish, and shortly thereafter he was operated on for a bone infection. He died of tuberculosis.

Stjepan Stolnik (Born 1931)
Page 58; Plate 28.

Stolnick lives in northern Croatia, Yugoslavia. His paintings display an interest in tonal contrasts, often coupled with a use of exotic or unexpected colors.

Louis Vivin (1861 – 1936)
Page 42; Figures 4, 46; Plate 13.

Vivin's first pictures were a series of landscapes of the area near his birthplace, Hadol, France. As an employee of the French postal service from 1879 to 1922, he traveled frequently, earning the rank of inspector and the ribbon of the *palmes académiques* for a series of maps of French postal districts (which was never published). Vivin moved to Paris in 1889, where he lived with his wife in Montparnasse. He visited the Luxembourg galleries and the Louvre, where he was impressed by Corot, Courbet, and particularly Meissonnier's sense of detail and literal illustration. Vivin's earlier work is generally active in mood and narrative in content, while his later work is more static, concentrating on blocks of color and form. He exhibited one painting, *The Pink Flamingo,* at an exhibition of pictures by postal clerks in 1889, and after 1925 he had works shown in Paris galleries through the support of Wilhelm Uhde.

Clara McDonald Williamson (1875 – 1976)
Page 52; Figure 62.

Williamson was born in Iredell, Texas, a small frontier town. She worked on her parents' farm, attending school when possible, until she moved to Waxahachie, Texas, in 1895 to work for her uncle. Seven years later, when her uncle lost his job as a county clerk, she returned to Iredell. In 1903 she married the widower John Williamson, a merchant with two children, and gave birth to her only child, a son, two years later. The family moved to Dallas in 1920. After her husband's death in 1943, Williamson began sketching, eventually attending drawing classes, first at Southern Methodist University and later at the Dallas Museum School. She had her first one-woman show in 1948 at the Dallas Museum of Fine Arts.

The following books are used to identify works of art in the Lists of Illustrations and Color Plates. References give the author's name followed by the number assigned to the piece in question.

Arkus, Leon Anthony, ed. *John Kane, Painter.* Pittsburgh: University of Pittsburgh Press, 1971.

Black, Mary, and Barbara C. and Lawrence Holdridge. *Ammi Phillips: Portrait Painter 1788 – 1865.* New York: Clarkson N. Potter, Inc., 1969.

Kallir, Otto. *Grandma Moses.* New York: Harry N. Abrams, Inc., 1973.

Rodman, Selden. *Horace Pippin — A Negro Painter in America.* New York: The Quadrangle Press, 1947.

Vallier, Dora, and Giovanni Artieri. *L'opera completa di Rousseau il Doganiere.* Milan: Rizzoli Editore, 1969.